THE SOMERSET & DORSET RAILWAY

THROUGH TIME

Steph Gillett

AMBERLEY

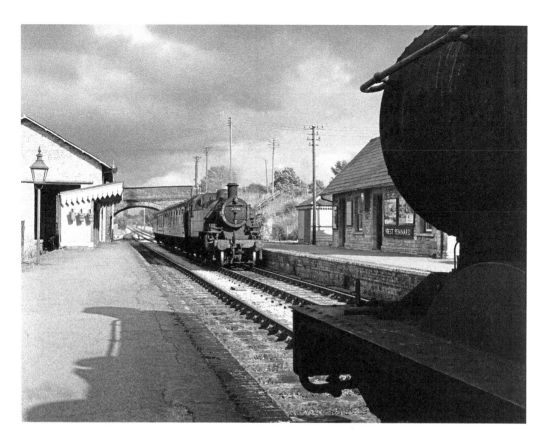

Photograph by Ted Salthouse.

For Francis and Amber-Ruth.

Back cover image, bottom: Courtesy of Nigel Davies.

First published 2016

Amberley Publishing
The Hill, Stroud, Gloucestershire, GL5 4EP
www.amberley-books.com

Copyright © Steph Gillett, 2016

The right of Steph Gillett to be identified as the Authors
of this work has been asserted in accordance with the
Copyrights, Designs and Patents Act 1988.

ISBN 978 1 4456 5037 1 (print)
ISBN 978 1 4456 5038 8 (ebook)

British Library Cataloguing in Publication Data.
A catalogue record for this book is available from the
British Library.

Typesetting by Amberley Publishing.
Printed in Great Britain.

Introduction

The publication of this book comes fifty years after the closure of the remaining routes of the former Somerset & Dorset Railway (referred to as the S&D from hereon). Apart from some short freight-only sections that remained open for a few more years, 1966 marked the end of the S&D as a public railway.

It was a sad day (in fact the weekend of 5 and 6 March 1966) for passengers, railway staff, their families, and enthusiasts alike when the S&D closed after more than 100 years of operation. The line had for a long time appealed to photographers and others, attracted by diverse classes of steam locomotives as well as varied and challenging operating arrangements. Ivo Peters, whose photographs and films chronicled the railway during the 1950s and 1960s, is best known though there were many others who recorded the line through images and sound. Yet for much longer the railway was a vital and valued link between communities throughout the two counties, some very small and isolated, and very few large. Its closure was opposed locally and nationally and led to some dramatic and poignant protests.

Interest in the S&D now is at least as great as it was at its closure. What is it that generates this enthusiasm for a long-dormant railway, even for those who never knew it open? Certainly it has a fascinating history and some unique aspects. It was Britain's second-longest joint railway, with classes of locomotives built specially for it, and it is famous for its Prussian blue livery (short-lived though it was). Had it survived the Beeching closures of the 1960s and existed today as a diesel-run line it might perhaps not have its present iconic status.

My own first experience of the S&D was as a very young child, travelling from Bristol to Bournemouth in 1957 for a family holiday. My only memory of the journey is of trying to drink milk from a glass bottle in the compartment. In later years my sister and I would be put on the train in Bristol and the guard asked to keep an eye on us as we made our unaccompanied journey to relatives in Bournemouth. I recall that by the last holiday trip in 1965 I was rather disappointed not to end up at Bournemouth West, as the line from Branksome was by then closed in anticipation of electrification of the Waterloo to Bournemouth line.

On some previous occasions we would be collected by our uncle and aunt and driven by car. This meant passing through Shepton Mallet, where my memory is of the Babycham deer on top of their factory rather than the magnificent Charlton Road viaduct. I do remember being very disappointed on one journey when we were stopped at Evercreech Junction level

crossing, only for the signalman to decide that the expected train was still some distance away and allow us through without seeing the anticipated steam locomotive.

There were also trips from Bristol with the school railway society in December 1964 and May 1965. Returning from the first trip on the 3.40 p.m. from Bournemouth West, hauled by BR Standard Class 5MT 4-6-0 No. 73051, a loaded cattle truck was attached at Shepton Mallet. I only took one trip on the branch, again in the mid-1960s, by which time Evercreech Junction had ceased to be the centre of activity it once was and there was a long wait for the train to Highbridge with little happening. A day out in the car with my mother's cousin Ted in 1965 included visits to Radstock and Templecombe, and I believe Midford on the way home where pennies were placed on the rail to be flattened by the train.

The famous 7F 2-8-0 locomotives had all been withdrawn by the time I visited the S&D as an enthusiast. My first encounter with them was at Woodham Brothers' scrapyard at Barry Island some time before the first, No. 53808, was rescued in 1970 and displayed at a Bristol Bath Road diesel depot open day.

In fact, I only ever knew the line in operation as a child, becoming a teenager the day before the final public trains on 5 March 1966; I did not witness these or any of the special trains the following day. My final visit had been in January or February 1966, during the so-called 'emergency service'. With one or two other train spotters, we walked round the engine sheds at Bath Green Park unchallenged. The lack of trains meant we were unable to travel back to Bristol on the Midland line. Perhaps because of my failure to attend the 'last rites' in 1966, I decided to walk the S&D to mark the twenty-fifth anniversary of closure in March 1991. The walk from Bath to Poole took six days for the 67 route miles and some of the photographs that follow are from that expedition.

The story of the S&D, as its name suggests, begins in two counties but chronologically we start in the Somerset Levels during the mid-nineteenth-century development of railways in the south and west of England. The Bristol & Exeter Railway (B&ER) was built to Brunel's broad gauge of 7 feet ¼ inch (2,140 mm) and opened to Highbridge and Bridgwater in June 1841, reaching Taunton the following year. It was to this line that civic and commercial interests in Glastonbury looked as a way of gaining an efficient transport link with Bristol and beyond.

James Clark, who with his brother Cyrus had a thriving footwear business in Street, C. & J. Clark Ltd, called a public meeting in September 1850 at which a provisional committee was formed. This meeting was chaired by William Pinney, who was earlier involved in the projected Somersetshire Midland Railway (SMR), unsuccessfully promoted in 1845 at the start of railway mania. The SMR proposed to connect Frome, Shepton Mallet, Wells, Glastonbury and Highbridge.

Exploratory surveys were carried out and in June 1851 the provisional committee's proposals were endorsed. By the end of 1851, directors for the Somerset Central Railway (SCR) had been appointed, including James and Cyrus Clark and two directors from the B&ER, seeing the new line as an opportunity to extend broad gauge territory. Over 100 years later, James Clark's role in helping to create the SCR was recognised when 246 descendants of his family gathered to mark its centenary. The SCR was established by an Act of Incorporation in June 1852 which provided for a line of 12 miles 26 chains (approx. 20 km) from Glastonbury to Highbridge Wharf on the River Brue. Despite the greater significance of Bridgwater and its superior harbour, Highbridge

was chosen as this would provide an easier route across the Somerset Levels and avoid crossing the Polden Hills. The Act also allowed for an extension from Glastonbury to reach the Wilts., Somerset & Weymouth Railway (WS&WR), but the actual route was not determined.

Construction began in 1853, with the first sod being formally cut on 18 April. Problems arose laying the line across the turf bog near Shapwick. The solution was to introduce bundles of sticks, which resulted in a firm but pliable trackbed. This was similar to the method employed by the Liverpool & Manchester Railway at Chat Moss a quarter of a century before.

Possible competition for trade from the Glastonbury Canal was removed by simply closing it in July 1854; the previous owners, the B&ER, had passed it to the SCR in exchange for shares in the latter company. The harbour tolls at Highbridge were also reduced to encourage business on the new railway.

The official opening of the SCR took place on 17 August 1854 amid much celebration at Highbridge, from where the first train, hauled by B&ER 2-2-2 tank locomotive No. 33, began the thirty-five-minute journey to Glastonbury. A procession through the ruins of Glastonbury Abbey marked the railway's arrival with banners reportedly proclaiming 'RAILWAYS AND CIVILISATION' and 'WHERE THER'S A WILL THER'S A WAY' (sic). It opened to regular traffic on 28 August, the broad gauge line being operated on behalf of the SCR by the B&ER, probably using their 2-2-2 and 4-4-0 tank locomotives for passenger trains and 0-6-0 tender engines for goods. By the end of 1854 the directors were looking to extend the line beyond Highbridge to Burnham-on-Sea and also to Wells.

Meanwhile, meetings were being held in Bournemouth and Poole that would lead to the Dorset sections of the S&D. The Southampton to Dorchester Railway had projected a branch to Blandford from its own line at Wimborne in 1847 and it was this proposal that was now revisited to become the Dorset Central Railway (DCR). The SCR extensions to Burnham and Wells were authorised in July 1855 and later in the year the directors began to consider options for creating the anticipated link with the WS&WR, which was operated by the Great Western Railway (GWR), and would provide the SCR with a link to the south coast.

Despite representations in support of an option through Wells to Frome via Shepton Mallet, a route to Bruton was adopted, due to easier gradients and lower construction costs. This line was authorised by an Act of July 1856. The people of Wells then looked to the East Somerset Railway (ESR), already authorised to build a broad gauge line from Witham to Shepton Mallet, to add an extension to serve their town (subsequently authorised in 1857). This put pressure on the SCR to complete their extension to Wells, which was intended to connect with the ESR. This junction was cancelled before the ESR reached Wells in 1862, and the stations of the two railways remained unconnected for sixteen years.

The Act of Incorporation of the DCR in July 1856 (shortly after that for the SCR extension to Bruton) allowed for a 10¼-mile (16.5 km) line to Blandford, which would bring the two railways within 24 miles (38.6 km) of each other. But the DCR was to be built to the narrow (later standard) gauge of 4 feet 8½ inches (1,435 mm). If only I. K. Brunel had adopted the track gauge introduced by George Stephenson some thirty years earlier it would all have been so much easier, but the railway map of south and west England would probably have looked very different as a result.

From the beginning the two railways had a close relationship, track gauge apart, sharing some officers. It was clear that the DCR wished to link with the SCR and reach the Bristol Channel and access South Wales traffic. One of the DCR directors, Sir Ivor Guest, was the son of a Dowlais ironmaster and rails from Dowlais were to become an important traffic on the S&D's cross-Channel shipping service.

The first sod of the DCR was cut at Blandford St Mary on 13 November 1856 by Lady Smith of Down House. The following February the SCR announced it would construct its new line to Bruton as narrow gauge in anticipation of a link with the DCR. In August 1857 the DCR was authorised to extend to meet the SCR at Bruton, establishing the desired coast-to-coast route. Creating a rail link between the English and Bristol channels had been the aspiration of several previous proposals (eg the Bristol & Poole Harbour Railway of 1846), to provide an alternative to the dangerous coastal route round the south-west peninsula.

The branch to Burnham opened on 3 May 1858, where a 900-foot slipway (274 m) was provided rather than the pier originally planned. Goods wagons were hauled up the 1 in 23 incline by wire rope, but there seems to be no suggestion that passenger carriages used the slipway. The B&ER agreed to work this and the Wells branch (opened in March 1859) until their existing lease of the SCR expired. The SCR now had 19 miles (30.6 km) of line and a further 13½ miles (21.7 km) authorised. The DCR line from Wimborne to Blandford was opened to public traffic in November 1860, being worked by the London & South Western Railway (L&SWR) for a percentage of receipts until August 1863.

The SCR had intended to convert their line to narrow gauge, being a cheaper option than laying mixed gauge track. However, broad-gauge interests forced a change to the 1861 Act to require both broad and narrow gauge to be provided on the extension and connection with the WS&WR at Bruton, as originally authorised.

In 1860 the SCR began to run passenger steamers, the ships from Burnham taking 1¼ hours to reach Cardiff. The service continued until 1888, but was not very profitable. The failure of the Burnham Tidal Harbour & Railway Company to construct the authorised quays and docks cannot have helped. The cargo services from Highbridge Wharf were more successful, and continued to send agricultural and dairy produce to South Wales and other Bristol Channel ports until 1933. Goods brought from South Wales included coal and iron products.

As well as building the line to Bruton, the SCR had to attend to other developments ahead of running narrow gauge trains to and on the DCR, not least acquiring locomotives and rolling stock. An order was placed with George England of London for eight engines, delivered in 1861. Seven were 2-4-0 tender locomotives and one a 2-4-0 tank engine that had the distinction of subsequently being rebuilt four times in three different forms. Carriages were ordered from John Perry of Bristol and Joseph Wright of Birmingham, and goods wagons from Rowland Brotherhood of Chippenham. Workshops to repair and maintain the locomotives and rolling stock were planned at Highbridge, to open from 1862. Also at Highbridge, a new station was required; SCR trains had been using one of the platforms at the B&ER station, though it is doubtful if all of the five platform faces subsequently provided could ever have been fully justified. Offices were also established in Glastonbury from 1861 in the Abbey Arms & Railway Hotel.

Despite all this activity, neither the line nor the rolling stock was ready when the B&ER lease expired in August 1861. The B&ER then agreed to hire stock to the SCR so it could continue the broad gauge service between Burnham and Wells until the narrow gauge rail was in place. There was also an agreement for the B&ER to run a daily broad gauge passenger train from Bristol to Wells via Highbridge, and a daily goods train to Cole (the SCR station serving Bruton), taking a percentage of receipts. This arrangement continued until 1868, though it is thought unlikely that the connection at Bruton was ever completed so no broad gauge traffic was exchanged here with the WS&WR or GWR. The extensions to Cole from Glastonbury (SCR) and Templecombe (DCR) were opened to traffic on 3 February 1862, both lines incidentally entirely within Somerset, the DCR making a junction at Templecombe with the Salisbury & Yeovil Railway (S&YR) whose station opened in 1860. The SCR operated narrow gauge trains throughout both sections; their motive power at this stage (and until 1874) comprised entirely of small 2-4-0 tender and tank locomotives, mostly from George England.

By late 1859 the SCR directors had already discussed formal links with the DCR, including mutual running powers over the two railways. At a special general meeting in February 1861 it was agreed to seek amalgamation with the DCR. In July 1862 the directors of both companies met in London, and amalgamation of the SCR and DCR as the Somerset & Dorset Railway was effective from 1 September 1862. The first meeting of the new S&D board took place in October 1862 at the Virginia Ash Hotel, Henstridge. Robert Read and Charles Gregory continued the roles they had held in both previous companies as Secretary and Engineer respectively. The SCR had existed for just ten years as an independent concern, the DCR for an even shorter period. When the final link in the DCR from Templecombe to Blandford was eventually opened on 31 August 1863, it was as part of the S&D.

The new company was then faced with the challenge of operating some seventy-odd miles (110 km) of narrow gauge railway, for which more rolling stock was needed but money to pay for it was in short supply. Nevertheless, more carriages were ordered from Joseph Wright (the Metropolitan Railway Carriage & Wagon Co. from 1863). Six 2-4-0 tender engines were ordered from the Vulcan Foundry, similar to those from George England but larger. However, the company could only afford to take delivery of two of them in 1866.

The original DCR station at Templecombe was at right angles to the S&YR line and at a lower level, so arrangements for the exchange of traffic between the two railways led to a series of challenging operating conditions. Connection with the S&YR (first operated by the L&SWR and then absorbed in 1878) was at first by a spur from the north joining the Salisbury line east of the S&YR station. From 1862 the L&SWR ran a shuttle service between the S&D's Lower station and the S&YR's Upper; some S&D trains also worked to the Upper station, all traffic having to reverse via the spur.

With completion of the remaining section of the DCR from the south, the line passing under the S&YR to reach Templecombe Lower, further complication arose, as trains from Blandford could not reach the Upper station without reversing twice. With traffic increasing on both the S&D and S&YR, this arrangement was not sustainable. The solution, such as it was, still required the reversal of S&D trains to gain or leave the Upper station, almost as difficult to describe as

it was cumbersome to operate. The arrangement must have baffled unfamiliar passengers and caused headaches for the operating department, but delighted future railway enthusiasts.

In July 1866 the S&YR was authorised to lay a new spur from the Upper station to join the S&D line from the west, north of the Lower station; a junction on this spur ran south past the Lower station. S&D trains began using the new link from April 1870, after which the original spur to the east was abandoned. Southbound trains were then able to run directly into the north face of the S&YR platform, but had to be drawn back out of the station by a pilot locomotive past the junction before continuing towards Blandford. Conversely northbound trains had to reverse into the Upper station, again with the aid of a pilot engine.

The Lower station continued in use until 1887, after which the buildings became part of the motive power depot. Templecombe was not the only station where reversal was necessary. Trains from the north had to do so at Wimborne to gain the L&SWR line to Poole to complete the coast-to-coast service from Burnham and vice versa.

The first Poole station, opened in 1847, was on the northern shore of Poole harbour. It was from Poole Quay that the S&D operated steamers to Cherbourg to provide a passenger service from France to Bristol Channel ports. But the service was not profitable and after operating in the summers of 1865 and 1866 it was suspended. In fact the Channel-to-Channel rail link itself did not produce the hoped-for business, and the company was already looking for ways to generate new traffic. Linking with the important trade centre of Bristol and the north Somerset coalfields was seen to provide new opportunities.

Already in 1859 the DCR had hoped the B&ER would lay a third rail from Highbridge to provide narrow gauge trains with access to Bristol. Three years later the SCR was still pushing for this, but without success, though the B&ER later proposed laying a third rail over the whole of their system. The S&D would need to find an alternative route to Bristol, but geography in the form of the Mendip hills, rising to over 1,000 feet (325 m), limited their options. Then began a period of proposal and counter proposal as the S&D and B&ER each looked for commercial advantage over the other. In 1863 the S&D proposed extending their line from Wells through Cheddar and Axbridge to join the B&ER at Yatton and, with running powers over a third rail, reach Bristol. But, faced with the threat of a B&ER line from Uphill to Glastonbury and Wells in the middle of their territory, the S&D withdrew and left the B&ER to build the line from Yatton to Wells, so ending their chance of an approach to Bristol from the west.

A route to Bristol via the north Somerset coalfields was then considered. This traffic had already been tapped by the Somersetshire Coal Canal from 1805, and in November 1854 an 8¼-mile (13 km) broad gauge branch from the WS&WR had opened for mineral traffic from Frome to Radstock. In July 1863 the Bristol & North Somerset Railway to Radstock was authorised. During the next few years the S&D proposed or was associated with a number of schemes which would have extended the Bristol & North Somerset line to join the S&D via Shepton Mallet, and thereby provide the desired direct route to Bristol. But all came to nothing and by 1866 the company's finances were in such dire straits that the S&D was placed in administration. The receivers were not discharged until 1870, around which time the last broad gauge rails were removed (twenty-two years before narrow gauge became standard gauge when the last GWR broad gauge lines were converted). The failure of the S&D to develop Burnham as

a port, and its route through thinly populated rural areas, meant it led a hand-to-mouth existence, stretched to pay for new locomotives or rolling stock to carry any potential new traffic.

In August 1869 an alternative route to expansion and hoped-for salvation emerged when the Midland Railway (MR) arrived at a temporary station in Bath, at the end of a branch from Mangotsfield on its Birmingham to Bristol line. The handsome terminus at Bath's Queen Square (later Bath Green Park) opened the following May. The S&D proposed a 25¾-mile (41.4 km) line from north of Evercreech station to reach the MR at Bath, which was authorised in August 1871. As with the rest of the S&D, this was to be a single-track line. By this route the railway would also gain access at last to the Somerset coalfields. A further Act of August 1873 allowed for further penetration with a branch in the Nettlebridge valley, but this line was not built and was finally abandoned in 1878.

There were developments too at the southern end of the S&D. The Poole & Bournemouth Railway, with which several S&D personnel were involved, was authorised in 1865 to construct a line from New Poole Junction (later Broadstone) which by arrangement with the L&SWR opened to a new station in Poole on 2 December 1872. The original Poole station west of the harbour became Hamworthy Goods Station and the junction was renamed accordingly. The line was extended to Bournemouth West, opening on 15 June 1874, and transferred to the L&SWR in 1882. Trains from the S&D now had access to the growing holiday resort of Bournemouth but still had to reverse at Wimborne until the Corfe Mullen cut-off was opened for goods in 1885, and for passengers in 1886.

Under the terms of the 1871 Act the S&D bought the Somersetshire Coal Canal Tramway and was able to use some 6 miles (9.6 km) north from Radstock, but construction of the Bath extension was otherwise an engineering challenge, with long sections at a gradient of 1 in 50, four tunnels and substantial viaducts. Nevertheless the line was completed in only two years, opening on 20 July 1874, with the original main line to Highbridge and Burnham then becoming the branch. As with the opening of the SCR twenty years before, the first S&D train from Bath was greeted by enthusiastic crowds, banners and the ringing of church bells. It had been an interesting two decades since James Clark and others had initiated the railway in Glastonbury.

But any celebrations were to be short-lived. In building the Bath extension the S&D had exhausted its resources and had insufficient funds to pay its debts or exploit the new traffic opportunities. There seemed to be no option but seek a takeover by a larger company and so, at the board meeting in July 1875, it was announced that negotiations had begun with the GWR and B&ER for taking over the line. Perhaps in the spirit of the earlier proposed Quadruple Agreement, which included the L&SWR, the broad gauge companies approached the narrow gauge concern with a view to it taking over the line south of Templecombe. But in an episode redolent of present-day boardroom tactics, the L&SWR met with the MR and proposed more favourable terms than the GWR/B&ER offer. These were accepted by the S&D board on 20 August 1875, just eight days after the approach to the L&SWR. Terms were agreed for a 999-year lease to run from November 1875 and, despite protest by the GWR, these were approved by Parliament in July 1876.

The railway had already been dubbed the 'Slow & Dirty Railway' by a local newspaper and the leasing companies had much to do to improve the infrastructure and services. Within

a month of the Act confirming the lease, a serious accident near Radstock highlighted some of the line's shortcomings. On the night of 7 August 1876 a return excursion train from Bath and a relief train from Wimborne collided head-on near Foxcote signalbox, killing thirteen people and injuring another thirty-four. The disaster resulted from the inadequate control of trains entering the single-line section, but was symptomatic of the disorganised state of the railway as a whole.

Following the accident the headquarters were relocated from Glastonbury to Bath, the L&SWR took responsibility for the permanent way, and the locomotive department came under the control of the MR. Some repair work continued at Highbridge Works, where the carriage and wagon department remained. Robert Read was appointed secretary and general manager for the Joint Committee now formed, continuing roles he had occupied since the opening of the SCR. Robert Armstrong Dykes was appointed superintendent of the line in 1876 and by the end of the nineteenth century had transformed the line into one fit for the twentieth. A subsequent staff appointment in November 1889 that was to bring many benefits to the line was that of Alfred Whitaker, who served as locomotive superintendent until retiring in 1911, during which time he made great improvements to the works at Highbridge. Whitaker also introduced the S&D single-line token exchange equipment, of which more later.

The S&D locomotive stock available to the leasing companies in 1875 consisted of twenty-six engines, mostly of 2-4-0 design dating back to the 1860s (including eleven by George England & Co.), that carried out the main line duties. Six 0-6-0 tender locomotives built by John Fowler & Co. of Leeds and five 0-6-0 saddle tank engines by Fox, Walker & Co. of Bristol had been acquired in 1874 for working freight trains and banking duties on the Bath extension respectively. New MR-type 0-4-4 tank and 0-6-0 tender locomotives were ordered to replace S&D engines now less able to cope with the demands of the line.

After 1876 the situation at Wells, which had acquired three separate stations by unconnected railways, became somewhat less complicated. The GWR had absorbed both the B&ER and ESR, and following conversion to narrow gauge of their branches from Yatton and Shepton Mallet they were linked by using S&D rails through the S&D Priory Road station. GWR traffic then used the station at Tucker Street, reducing the station count to two. Exchange of goods traffic between the two companies began and the GWR through service from Yatton to Witham commenced in January 1878. It was not until 1934 that their passenger trains called at the S&D station.

There had been several unsuccessful attempts to reach Bridgwater, the SCR having originally settled on Highbridge. Proposals for a branch from Shapwick in 1866 and 1875 were rebuffed by the B&ER and the Joint Committee turned down another proposal in 1880. In the end it took two Acts, in 1882 and 1888, to establish the technically independent Bridgwater Railway. The branch from Edington Junction (formerly Edington Road) finally opened on 21 July 1890 and was worked as part of the S&D system. It was acquired by the L&SWR in January 1923. This final extension brought the S&D to 102 route miles (163 km) and a further 11 miles (17.6 km) of running powers over L&SWR and MR lines to Bournemouth and Bath.

Ownership of the S&D effectively passed to the leasing companies in 1891 following legislation that allowed the exchange of S&D shares for MR stock. The last meeting of the old

board took place on 3 April 1891, attended by James Clark, the only director remaining from the original SCR board. A new board comprising equal numbers of MR and L&SWR members was appointed, and Robert Read retired after serving the railway for thirty-seven years.

A programme of doubling the main line began in order to cope with increasing traffic. The first section, from Midford to Wellow, was completed in August 1892 and the last, from Bailey Gate to Corfe Mullen, in February 1902. This left as single-track the sections from Bath Junction to Midford, Templecombe to Blandford, and Corfe Mullen to Broadstone. The challenge of doubling Devonshire and Combe Down tunnels (as had been done at Chilcompton and Winsor Hill) evidently defeated the railway, though Tucking Mill viaduct was widened in anticipation of an additional track; the Bath to Midford section remained a bottleneck to the end. Tyer's electric tablet system had been introduced in 1886 to control trains on the single-track sections, which eventually comprised about a third of the main line and all of the branch lines. Whitaker's automatic tablet apparatus, which allowed trains to exchange tokens for the single-track sections at speeds of up to 60 mph, was introduced from 1904 (patented 1905) and was instrumental in accelerating train services. The Wimborne avoiding line also allowed the acceleration of services. The fastest train from Bath to Bournemouth, which ran non-stop to Poole, took 103 minutes in 1903 but by 1906 this had been reduced to 96 minutes.

Within twenty-five years of opening the Bath extension, traffic over the S&D had practically doubled. It was in the interest of both MR and L&SWR to put as much traffic over the line as they could, much freight being exchanged at Bath and Templecombe. Through carriages were running between Bournemouth and York, Bradford, Sheffield, Derby and Birmingham, and summer excursions ran from many parts of the north of England to destinations on the L&SWR. The forerunner of 'The Pines Express' from Manchester to Bournemouth was introduced in October 1910 by the MR (with the London & North Western Railway) in response to the GWR including a through coach from Manchester in its service from Birkenhead to Bournemouth via Oxford. The 'Pines Express' was named in 1927 after the pine trees growing round Bournemouth.

To deal with increasing train loads and improved timings, the first of a series of elegant Victorian and Edwardian 4-4-0 tender locomotives was designed by S. W. Johnson and built at Derby in 1891, introducing a wheel arrangement that remained associated with the S&D for another seventy years. They could haul trains of eleven six-wheel carriages between Bath and Bournemouth in just over two hours, including seven stops en route. The 0-4-4 tank engines of 1877 were then mostly relegated to branch line services. By 1900 locomotives and carriages were being turned out in the famous Prussian (or Royal) blue with gold lettering and lining.

Through freight services between the North and South-West could account for over 1,000 wagons a day. Over 200,000 wagons were reputedly transferred at Templecombe in 1910. The most important non-passenger traffic generated along the S&D itself was dairy produce, principally milk to London and south-east England, up to 28,000 churns being despatched in one month. Other goods traffic generated locally included: coal from north Somerset collieries, limestone from Mendip quarries, Fuller's earth from Midford and Wellow, bricks from Burnham and Bridgwater, beer from Shepton Mallet and Binegar, and Cheddar cheese and footwear products from Glastonbury.

Regular traffic continued to grow until the outbreak of war in 1914, but it was generally a period of consolidation rather than new developments, while increased income was largely off-set by increased running costs. Developments along the line included a 2-foot, 6-inch (762 mm) gauge tramway from Binegar to serve Oakhill Brewery in 1904 (closed in 1921) and the Wilts. United Dairies milk factory at Bason Bridge in 1909. In August 1905 Burnham pier finally passed to the local council. The railway had been negotiating with the council to take it over since 1899, following abandonment of passenger steamer services. But the S&D cargo vessels at Highbridge were still being kept busy.

A very significant event in 1914 was the introduction of the first six of a series of 2-8-0 freight locomotives designed specifically for the S&D and forever associated with the line. Prior to this the MR had provided motive power for the S&D that followed Derby practice of 0-6-0 and 4-4-0 wheel arrangement. The new engines were designed by Henry Fowler and James Anderson in response to an appeal from the S&D locomotive superintendent, Whitaker's successor M. F. Ryan, for larger locomotives that could handle mineral traffic from Radstock to Bath and over the Mendip gradients without double-heading. Although the 2-8-0s had many Derby features, they had a distinctive appearance unlike any other MR engine, with steeply inclined outside cylinders, and a higher tractive effort than any other MR locomotives at the time. They were equipped with tender cabs to provide the crew with protection when running in reverse, but these were removed around 1920, even though sufficiently large turntables were not provided at Bath and Evercreech Junction until 1934. A further five of the class were built by Robert Stephenson & Co. in 1925. Originally these later engines had larger diameter boilers than the first batch, but all had received the smaller boiler by 1955. When introduced, the 2-8-0s were turned out in unlined black livery, which was increasingly becoming standard for freight engines from 1914. The last of these engines were finally withdrawn in 1964, but two of the later series, original numbers 88 and 89, were rescued from Woodham Bros scrapyard at Barry, South Wales, and preserved.

The 1914–18 war brought much traffic, with trainloads of munitions and later tanks heading south and the inevitable ambulance trains north to Bath. The timing of regular passenger services deteriorated as a result and holiday traffic was stopped. Many S&D staff served in the armed forces, 101 from Highbridge Works alone, thirteen of whom were killed. The names of some from the works who enlisted were found recorded in pencil on timber panels in one of the few surviving S&D carriage bodies. The official memorial to those who died in the conflict was unveiled at Highbridge Works on 8 May 1922 and dedicated by the Lord Bishop of Bath and Wells.

The passenger service to Wimborne was withdrawn in July 1920, although milk trains continued until February 1932 and goods until June the following year. The line was then closed at the Wimborne end, but a connection retained from Corfe Mullen to serve the clay pits at Carter's siding. Wimborne had effectively been on a branch of the S&D since the cut-off was opened in 1885/86. As elsewhere, there was increasing competition from road transport, which with economic depression led to a fall in revenues.

Following the Railways Act of 1921 and the subsequent grouping of railways, from July 1923 the S&D became jointly owned by the London Midland & Scottish Railway (LMS) and the Southern Railway (SR), the successors to the leasing companies. The Somerset & Dorset Joint Railway Company was then dissolved.

Most freight over the S&D continued to be through traffic from the LMS to the SR systems, but dairy was a very important local product, some 500,000 churns of milk reported in 1929 as being sent to London and south-east England in twelve months. Other commodities included milk powder from Evercreech, and condensed milk from Bason Bridge. In the Radstock area eight collieries were connected with the line, and the extensive peat moor between Glastonbury and Highbridge that in places extended to a depth of over 30 feet (9 m) provided additional traffic, served by a siding between Ashcott and Shapwick and a 2-foot (600 mm) gauge railway which problematically crossed the S&D on the level.

In addition to the second batch of 2-8-0 locomotives, the LMS provided further 4-4-0 and 0-6-0 tender engines for the S&D stock list. In 1929 seven 0-6-0 tank engines of standard LMS design were supplied from W. G. Bagnall Ltd of Stafford (the 'Jinty' to railway enthusiasts) to replace the 0-6-0 saddle tank locos of 1874. The same year saw two chain-driven 0-4-0 shunting engines from Sentinel of Shrewsbury to work within the low clearances and sharp curves of Radstock's colliery sidings. The Sentinels replaced three small tank engines built at Highbridge in the 1880s and 1890s, the only locomotives constructed in the S&D works.

The weight and frequency of express trains increased following the grouping, but there were no major changes until re-organisation in 1930 to reduce running costs. From January 1930 the eighty locomotives were taken over by the LMS, which then assumed responsibility for providing motive power. The rolling stock was divided between the LMS and SR; the former acquired 211 vehicles and 173, including the majority of coaching stock, went to the SR. The line also lost its distinctive blue livery; passenger locomotives began to be painted black and passenger stock became SR green.

Of much greater impact was closure of Highbridge Works from May 1930, major repairs then being carried out at LMS works. Highbridge had carried out repair and maintenance for the line for sixty-eight years, including the construction of carriages up to 1913, and the impact on the small town when around 300 men lost their jobs was significant. The war memorial installed with such ceremony just eight years before was moved to the S&D station. From July that year separate management of the S&D ended, the LMS taking responsibility for traffic staff and operating the line on behalf of the Joint Committee. The SR became responsible for maintenance, civil engineering, signalling and accountancy.

From the 1930s milk was being transported in specially constructed tank wagons. In early 1932 a new siding was provided at Bailey Gate for this purpose, United Dairies Ltd proposing to send 1 million gallons (4,546,090 litres) annually to Willesden, north-west London. The following year Wilts. United Dairies requested additional siding accommodation at Bason Bridge, reporting an increase in traffic from 1,069,866 gallons (4,863,707 litres) in 1931 to 1,489,149 gallons (6,769,805 litres) in 1932. However, in 1934 concerns were expressed about a general fall in milk traffic over the line.

In 1933 the S&D's remaining cargo vessels were sold, ending S&D shipping activity. The traffic officers, engineer and estate agents had all been tasked with identifying possible economies, including closure of the Bridgwater and Wells branches, though this was not felt to be justifiable. An interesting proposal for increasing ticket revenue through use of a light rail

car that could pick up and set down passengers at public level crossings, with a more frequent service, seems to have been lost in the subsequent wider use of the push-and-pull trains already introduced on the branches. It was felt that local traffic being lost to road transport could not be regained, even by offering cheap fares.

But it was not all retrenchment. 1934 was the first time in six years that passenger receipts had increased, due to 'summer' ticket arrangements introduced in May 1933, exceptionally good weather and the growth of excursion traffic with more and heavier trains from the Midlands and north of England. Special trains from the Midlands bringing thousands of racing pigeons for release, especially at Templecombe, were another important traffic. There were twenty-one such trains in 1931 during May and June. Sunday excursion traffic developed before the 1939–45 war, but this was not a situation that would have been permitted during most of the previous MR/L&SWR incumbency. Sunday passenger services had been provided by the SCR and DCR and on the S&D's Burnham to Poole route, but they were withdrawn from 1874 and the entire network closed on Sundays during the 1880s. This seems to have been more to do with commercial considerations than observance of the Sabbath. Requests from communities along the S&D were repeatedly rejected during the 1890s on the grounds of not being profitable. The railway relented slightly in 1905 in allowing passengers to use the milk train to Templecombe, the only traffic even by then permitted on Sundays, but this had to be withdrawn from the published timetable following legal challenges from a competing dairy. As late as October 1914 a request from Wellow residents for a Radstock to Bath Sunday service was declined, but by April 1919 stationmasters were to receive extra payments for working on Sundays.

Once construction of locomotive types specifically for the S&D had ceased, the LMS tried a variety of classes on the line, with varying degrees of success. From 1930 motive power reinforcement was mostly in the form of 2P 4-4-0 and 3F and 4F 0-6-0 tender engines, classes that had already proved their worth on the line. Work to strengthen bridges west of Bath was completed early in 1938, permitting access to the S&D for William Stanier's 5P5F 4-6-0 'Black Five' locomotives. Following a successful trial run from Bath to Bournemouth and back with a thirteen-coach train in March 1938, six 'Black Fives' were allocated to the line, some newly built. Their use reduced the need for double-heading, trains being allowed 270 tons, around eight coaches, without a pilot engine. However, most were relocated from 1941 to meet wartime needs and several classes of L&SWR and SR 4-4-0 engines, mostly of Drummond design, were provided as replacements. SR 0-4-4 tank locomotives were also provided for operating branch trains. Circumstances allowed the return of 'Black Fives' from 1944 and the line continued to have an allocation of the class until 1958.

The outbreak of war in 1939 once again disrupted traffic on the line, with a severe reduction in passenger services, though this had been improved slightly by May 1940 to something approaching the pre-war winter service with at least one through train. As one of the shortest routes from the industrial North and Midlands to the South Coast, it carried much equipment and war materials, hauled by the line's 2-8-0 engines, and many trains following the evacuation of Dunkirk in 1940. Concrete tank blocks and pill boxes were constructed along its route, many still remaining. An ambulance train, complete with London & North Eastern Railway locomotive, was stabled at Templecombe from around 1943 and preparations for the

Normandy landings (D-Day) in June 1944 saw much military traffic, bringing US troops to transit camps. The war also saw more women employed in roles across the railway previously occupied by men, excluding footplate grades.

The Transport Act of 1947 brought nationalisation of the railways from the following January, an event that began a chain of events that were to have a significant impact on the S&D. The first outcome was that with no owning company, the imperative to put traffic onto the line, which had been so important during the MR and LMS periods, no longer existed. The newly formed British Railways (BR) was likewise faced with trying to deal with its inheritance of competing routes, the legacy perhaps of a railway system built as much in response to commercial ambition as social or economic need. At first the line was allocated to the Southern Region, ie SR (BR), though Bath Green Park station and locomotive sheds remained part of the London Midland Region (LMR). The LMR was also responsible for motive power.

Petrol rationing after the war helped to restore railway holiday traffic to southern resorts and re-establish Bournemouth as a holiday destination for many families in the Midlands and north of England. A wide range of locomotive classes and combinations was used to maintain peak summer services during the 1950s, including increasing use of the 7F 2-8-0s, with through services from and to Bristol, Birmingham, Bradford, Cleethorpes, Clitheroe, Coventry, Derby, Huncoat, Liverpool, Manchester, Nottingham, Preston, Sheffield and Walsall.

In January 1950 the regional boundaries were amended, with the lines north of Cole coming under the Western Region (WR) and those to the south being part of the SR (BR), which still operated the S&D with locomotives loaned by the LMR. The motive power depots, however, transferred in February 1950 to the SR (BR), which constructed a new brick-built engine shed at Templecombe in 1951. In April 1953 the stock of nearly seventy locomotives, until then on loan, followed. Even this arrangement was apparently found wanting as in February 1958 the regional divide was moved again, to between Templecombe and Henstridge, though Templecombe station remained part of the SR (BR), and the WR took over the motive power and sixty-six locomotives. With WR management the line received its first allocation of ex-GWR motive power in the shape of 0-6-0 pannier tanks and Collett 0-6-0 tender engines, the latter replacing the old MR Johnson 3F 0-6-0s on branch trains; ironically it seems to have been a GWR pannier tank, No. 3681, that was one of the last locomotives to be in steam at Bath following closure. The engine sheds at Bath Green Park, Radstock, Highbridge and Templecombe had changed regional hands three times in ten years, their locomotives bearing as many different shed codes. Bath changed from 22C to 71G, and finally 82F. Templecombe's shed code changed yet again in 1963 from 82G to 83G.

Meanwhile closures were being implemented on the branches off the original SCR line. The line from Glastonbury to Wells closed on 29 October 1951; the average number of daily passengers had fallen to half a dozen and not many more goods wagons. The final train was hauled by former MR 0-4-4 tank engine No. 58086. Locomotives of this wheel arrangement had long been associated with the S&D. On the same day regular passenger services over the Highbridge to Burnham-on-Sea extension ceased, though excursions continued to run to Burnham until 8 September 1962, some via Bristol, and freight trains until 20 May 1963. The Bridgwater branch had also suffered a dramatic fall in traffic with just four trains a day, carrying

few passengers. The branch closed to passengers on 1 December 1952, just sixty-two years after opening. A daily goods train continued until 1 October 1954, by which time Edington Junction had been renamed Edington Burtle. The line was dismantled and lifted by 1956. Despite the loss of these 'twigs' on the branch, over 600 passengers joined a special train of twelve carriages on 28 August 1954 to celebrate the centenary of the opening of the SCR from Glastonbury to Highbridge. This was hauled by 3F 0-6-0 tender locomotive No. 43201, built for the S&D at Derby in 1896 and running under its original identity of No. 64, decorated with bunting and with the footplate crew sporting Victorian-style bowler hats and enormous false beards.

There is not space here to rehearse all of the arguments about the state of Britain's railways following nationalisation and the attitudes to rail and road transport of successive governments. But the appointment of Dr Richard Beeching as chairman of the British Railways Board in 1961 by the Conservative minister of transport, Ernest Marples (who was himself not only a keen supporter of road development but had commercial interests in road building), provided the environment that ensured closure of the S&D. His subsequent report, *The Reshaping of British Railways*, published in March 1963, earmarked the line for withdrawal of passenger services. But the end was a 'slow and dirty' process.

The final years of the line, though, provided much interest for the railway enthusiast and not a little frustration for the travelling public. A wide variety of locomotive classes were tried by the operating departments, some with more success than others. Ivatt Class 4MT 2-6-0 tender engines (nicknamed 'Doodlebugs') were not popular with the locomotive crews. The arrival of Ivatt's 2MT 2-6-2 tank engines was more welcome, and the S&D retained an allocation of them until closure. In 1951 the SR (BR) authorities allocated four Bulleid West Country Class light Pacific locomotives following trials with then nearly new Battle of Britain locomotive No. 34109 *Sir Trafford Leigh Mallory*, though they were not able to deal with the heavier trains unassisted over Mendip as hoped. The Bulleid Pacifics left Bath Green Park depot in 1954 to be replaced with three brand new BR Standard 5MT 4-6-0s, a class that became well-liked by many S&D loco men. They were equipped with Timken roller bearings, which required special training for shed maintenance staff to ensure proper lubrication.

Other BR Standard classes that came to the line in later years were the smaller 4MT Class 4-6-0 and 2-6-0 tender engines and the versatile 4MT 2-6-4 tank engines, which between them were handling most of the final passenger services. The allocation in 1960 of four BR 9F 2-10-0 tender locomotives was of much greater significance. Here at last was motive power able to haul heavy passenger trains unaided up the line's gradients. For three years these versatile engines dealt with the summer holiday traffic, greatly reducing the need for double-heading. But the 9Fs arrived too late to save the S&D, and their lack of steam heating precluded their use during the winter months. The WR had already begun to divert traffic from the line to other routes. Starting with the beer trains to the west of England from Burton-on-Trent, Staffordshire, through freight trains were gradually withdrawn. Fertiliser traffic from Avonmouth to Blandford ended up with a journey twice the distance. From 1962 the 'Pines Express' was re-routed via Oxford and Basingstoke; the last over the S&D on 8 September 1962 was fittingly hauled by the last steam engine built for BR, 9F No. 92220 *Evening Star*.

Bit by bit, the services on the line were pared down. By 1963 there were no through passenger services from the North and from September 1964 the main line was closed at night to all traffic. By June 1965 there were hardly any goods services other than coal trains from the few remaining north Somerset collieries. Despite the hope that the line might be reprieved when a Labour government came to power in 1964, the minister of transport finally confirmed closure of the line in October 1965. No amount of protest and objection was able to reverse the decision, and 3 January 1966 was announced as the final day. But insufficient time had been allowed for all the replacement bus services to be arranged and when one operator withdrew, closure had to be postponed. A scant and inconvenient interim service was provided using the twenty-one locomotives then allocated to the line while the alternative road services were confirmed, which brought yet more protests and criticism of the WR management. But closure was finally confirmed for 7 March 1966, which in fact became the first day when no passenger trains would run on the S&D.

The final day of scheduled services, Saturday 5 March 1966, was marked at Evercreech Junction by scenes of pathos. A wreath was placed on the front of the locomotive hauling the last passenger train to Highbridge by stationmaster Alexander Stowe; the wreath had been made by his daughter and a teenage boy. Station staff wearing mourning dress and mauve ribbons slow-marched a symbolic coffin to the strains of 'John Brown's Body' and placed it on the final train to Bath. The train's departure was marked by the mournful engine whistles competing with the sound of numerous exploding detonators placed on the rails.

This was not quite the end of the line for BR-operated services as several short sections were retained for freight trains. At Bath a section was retained to serve the nearby Co-operative sidings with coal until 1967. At Radstock the Down line was slewed to join the former North Somerset line, enabling coal trains from Writhlington colliery to gain the BR network via Frome. Writhlington colliery closed in September 1973, one of the last two coal mines in Somerset. Norton colliery had already closed in February 1966.

The factory at Bason Bridge, by then part of Unigate Foods, continued to send milk to London by rail, in 1969 sending around 20 per cent of its 17-million-gallon (77,283,530 litres) production in over 1,200 tank wagon loads. The connection to the WR main line at Highbridge was severed in 1972 by the M5 motorway; the company had unsuccessfully pressed for a rail bridge over the new road. As if in a final insult, part of the redundant site of the former works at Highbridge was used as a concentration depot for pulverised fuel ash from South Wales, used in constructing the motorway.

The milk factory at Bailey Gate also remained connected via Broadstone until 1969, as was Blandford for freight, some of which at least in 1966 was steam-hauled. Demolition of the rest of the line began soon after closure. Salvage contractors were given a contract at the end of 1966 for dismantling the 51 miles (81.6 km) between Bath and Shillingstone and track lifting on the branch began in 1967. Nevertheless, much of the infrastructure, including station buildings, remained intact by the mid-1970s and beyond, albeit vandalised and in a derelict state.

Many people held the WR responsible for closure of the S&D, but its demise was probably inevitable in light of the Beeching report and the economic and political climate of the 1960s. True, the WR had diverted traffic to other less direct routes and might have diverted more

but for objections from other regions, but arguably the line was doomed long before then. Certainly there were staff in the nationalised railway who still held allegiance to the pre-1948 companies, of which the GWR of all the pre-grouping railways had maintained its identity for over 100 years. But it is hard to see that being enough for WR staff to act simply in revenge for the L&SWR and MR action of some eighty years before. In fact, WR management had a plan to utilise six diesel multiple sets to maintain the passenger service on the line had the minister of transport, Barbara Castle, decided to reprieve the route in October 1965.

It is hard to see how the S&D could have survived the rationalisation of the railways in the face of the growth of road transport and car ownership and the subsequent fall of freight tonnage and passenger numbers. Add to that the operational difficulties caused by the gradients of the Mendips, single-line operation through a significant proportion of the route, and reversal of trains at Templecombe, and it is not difficult to understand the reasoning. The problems of operating the line in harsh weather, such as the particularly severe winter of 1962/63 that caused the line to be blocked by heavy snow falls, may have raised other questions about its viability.

In retrospect the S&D was ultimately the product of a number of initiatives at a time when railways were seen more as competing businesses than part of a more coherent public transport network. If the development of railways in Britain had been informed by a strategic national vision, it is questionable whether the S&D as built (along with many other routes) would have been considered. Conversely, other railways promoted at one time or another may indeed have come to fruition. Even as built, there was scope for interchange with the GWR once narrow gauge had become the standard, the two lines crossing five times between Bath and Cole. There were proposals for junctions over many years, but no connection was made except at Radstock, and that not until after closure, too late to create a joined-up system.

The end of steam operation on BR was already in sight by the 1960s. Regular haulage by steam locomotives ceased just over two years after closure of the S&D. Had the line survived into the 1970s it is possible that the political environment might have changed sufficiently for it still to be providing at least a passenger service. Certainly the use of diesel multiple units for passenger services would have eased the arrangements at Templecombe, given flexibility for trains to start from and terminate at intermediary stations, and reduced staffing requirements. But the viability of the northern section of the line to Bath Green Park possibly depended on links with Bristol and north to the Midlands being maintained, and the lines through Mangotsfield duplicated other routes. What freight traffic that remained could have been handled by diesel locomotives from WR and SR (BR) region fleets, though for how long such freight services would have been sustainable is another matter; possibly not into the 1980s. No doubt many of the stations would have become un-staffed halts, track layouts and signalling would have been simplified, and the atmosphere of the railway would have changed dramatically to something like that of the Central Wales Line today, perhaps.

Ironically, some of the communities once served by the S&D, such as Norton-Radstock, Shepton Mallet, Evercreech and Blandford, have now grown to the point that they might now support regular commuter services. The fly in the ointment for any project planning to reinstate a network rail link is that much of this housing development has been at the expense of the former trackbed. Highbridge and Burnham remain served by trains on the line from Bristol

to Taunton, and local pressure in Templecombe had services on the Salisbury to Exeter line reinstated at the station in 1983, but the former S&D platforms at both stations are long gone.

Since closure a number of preservation schemes have manifested themselves along the line, though not all have survived much longer than the short-lived DCR. First on the scene was the Somerset & Dorset Railway Circle, which was formed in the year of closure, and later became the Somerset & Dorset Railway Trust (S&DRT). The Circle negotiated with BR in 1969 for the use of station buildings and the engine shed at Radstock, and purchased 7F 2-8-0 locomotive No. 53808, which was first kept there. But plans to establish a steam-operated line to Writhlington were scuppered, partly by lack of finance and redevelopment plans for the site, and not a little 'red tape' along the way. Offered a home by the embryonic West Somerset Railway, the S&DRT decamped to Washford in 1976 and established a museum and restoration centre, albeit some distance from the nearest point of the S&D system at Bridgwater.

Later heritage railway projects are now established on the route at Midsomer Norton and Shillingstone stations, where the stations are being returned to something like their former glory. Restoration work has also taken place at Midford and Spetisbury stations, and the Gartell Light Railway runs narrow gauge trains on a section of the trackbed at Yentson south of Templecombe. The ambitious plans of others to re-open all of the S&D are very unlikely to be fulfilled, but as with all the preservation groups, it helps to keep the memory of the railway alive and protect at least some of the route, if only as a footpath or cycle way. And who can say for certain how we will be meeting our public transport needs during the next fifty years?

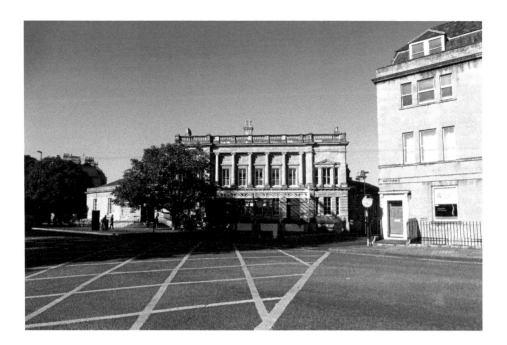

The Midland Railway's handsome station opened on 7 May 1970, its Victorian façade comparing well with the Georgian architecture of Bath. Known unofficially as Bath Queen's Square, it was renamed Bath Green Park in June 1951. It was restored in the early 1980s and is now a valuable cultural and recreational facility.

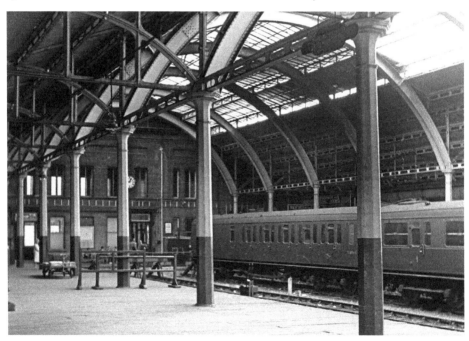

The station comprised two wooden platforms with four tracks between, partly under a glazed arched roof, and a circulating area as seen in this 1962 view looking towards the buffer. (John Eyers, South Western Circle, Eyers Collection, via S&DRT)

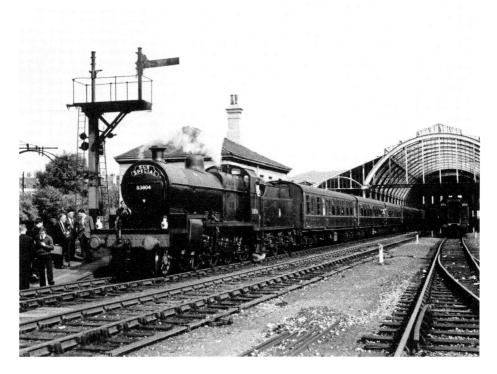

7F 2-8-0 No. 53804 waits at Bath Green Park's northern platform with an SLS (Stephenson Locomotive Society) special train to Templecombe and return on 11 September 1960. The building behind the locomotive was the HM Customs bonded store. (John Eyers, South Western Circle, Eyers Collection, via S&DRT)

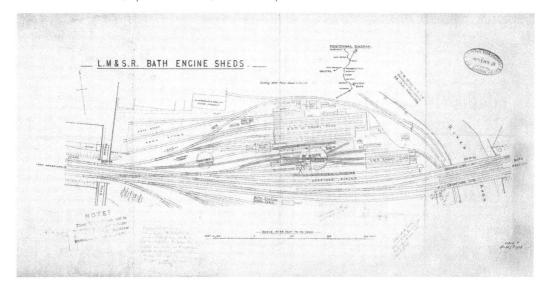

The S&D engine shed at Bath was a timber building covering four tracks. To its south and at a higher level was the coaling stage. The smaller two-road, stone-built MR shed was south-east of the S&D building. This plan dated 9 March 1934 shows the changes to the track layout to accommodate the later 60-foot (18.3 m) turntable. (Bath Record Office)

Bath motive power depot in May 1929 with 7F 2-8-0 No. 90, as built in 1925 by Robert Stephenson with the larger diameter boiler. This engine was renumbered 9670 by the LMS in 1930, the year it received its smaller G9AS boiler, and again in 1932 as 13810. (Anon, South Western Circle, Eyers Collection, via S&DRT)

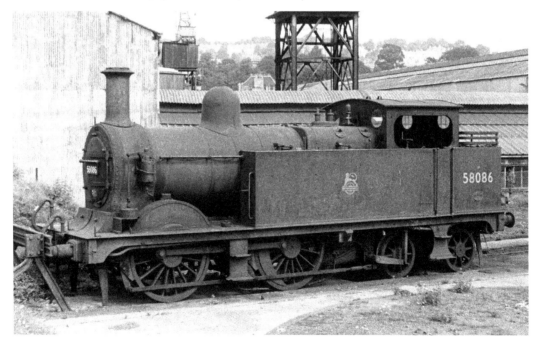

Midland Railway Johnson 1P Class 0-4-4T locomotive No. 58086 at Bath motive power depot in August 1959. It was the last survivor of the class when withdrawn the following year and thus the last engine of this wheel arrangement on the S&D. (Anon, S&DRT Collection)

Bath Junction, half a mile from Green Park station, marked the start of the S&D and the 1 in 50 climb to Devonshire and Combe Down tunnels and also the single-track section to Midford. The Whitaker tablet exchange apparatus can be seen in front of the signalbox. (Anon, S&DRT Collection)

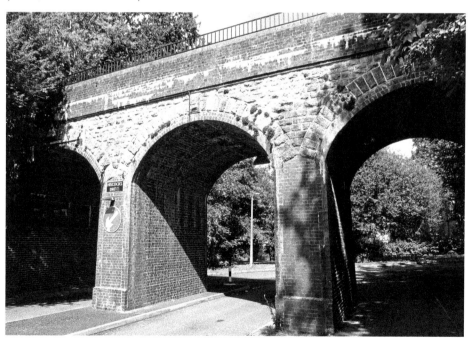

The Two Tunnels Greenway follows the trackbed from the southern outskirts of Bath, which has helped to secure the survival of the remaining bridges. Englishcombe Bridge is seen from Hiscock's Drive in September 2015.

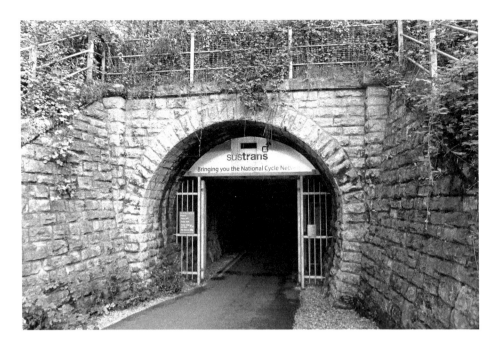

The north portal of the 440-yard (402 m) Devonshire tunnel as re-opened for public use as a Sustrans shared-use cycling and walking route in 2013. The single-bore Devonshire and Combe Down tunnels proved an insurmountable challenge to doubling the track of the northern section.

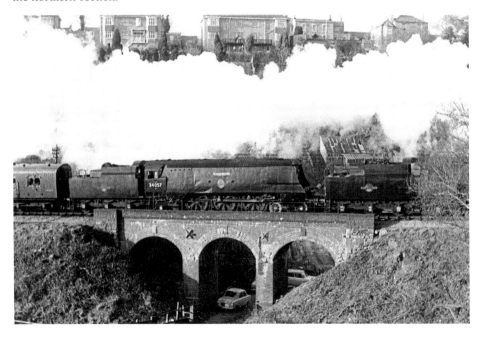

Watery Bottom Viaduct is occupied by Battle of Britain No. 34057 *Biggin Hill*, heading the returning LCGB (Locomotive Club of Great Britain) special with West Country classmate No. 34006 *Bude* climbing the 1 in 60 from Devonshire tunnel on 5 March 1966. The two engines took the train to Bournemouth Central. (Gordon Dando, S&DRT)

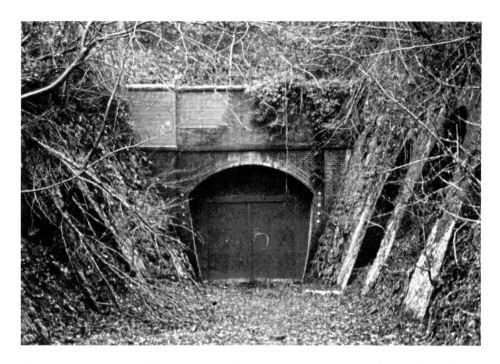

The south portal of Combe Down tunnel seen twenty-five years to the day after closure in March 1991. At 1,829 yards (1,672 m), it was the longest tunnel in Britain without a ventilation shaft and is now the longest cycling tunnel in Britain.

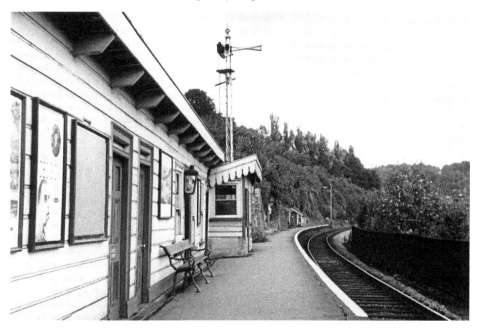

Midford station marked the end of the single-line section from Bath Junction. The Whitaker tablet exchanger was situated in front of the signalbox, which was rebuilt with a flat roof after being partially demolished by a runaway locomotive and wagons on 29 July 1936. (John Eyers, South Western Circle, Eyers Collection, via S&DRT)

Midford's single platform, built into the side of the hill, has survived but the buildings have long gone. Unlike others stations on the Bath extension, the station buildings were constructed from timber.

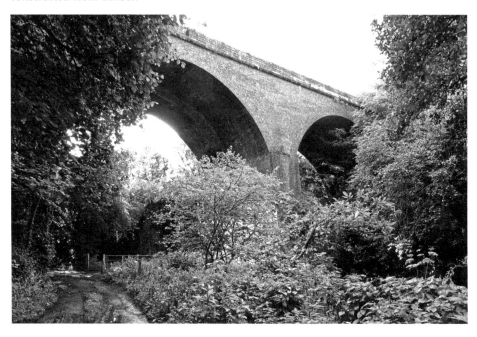

Midford Viaduct seen from the down side; the former GWR Camerton to Limpley Stoke branch (closed 1951) can be glimpsed under the left arch, through the trees. The eight-arch, 168-yard (153 m) bridge also crossed the Bath to Frome road, the Cam Brook, and the Somersetshire Coal Canal.

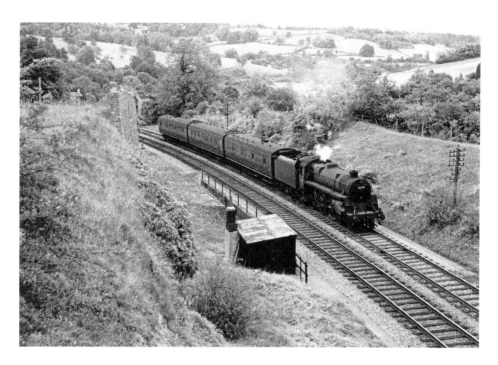

The 4.35 p.m. Bath to Templecombe train is seen south of Midford Viaduct at the beginning of the double-track section on 4 August 1962, behind BR 4MT 4-6-0 No. 75071. (John Woods, S&DRT)

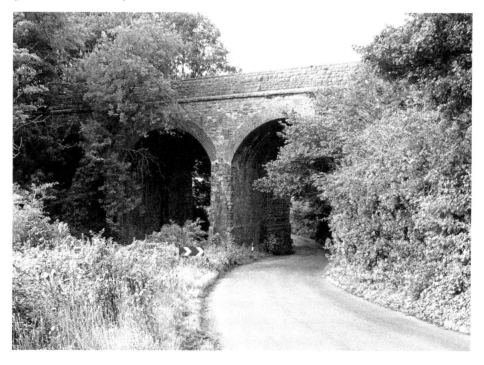

Wellow Viaduct seen from the south, i.e. the Down side. The different construction of the Up and Down bridge piers dates from doubling of the line in the 1890s.

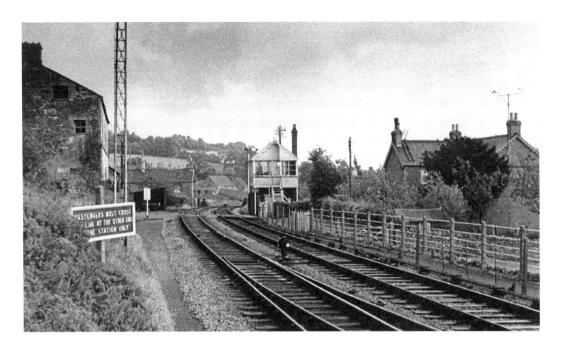

Looking up the line from Wellow station towards Midford in September 1961, the eighteen-lever signalbox can be seen in the centre, next to the level crossing it controlled. (John Eyers, South Western Circle, Eyers Collection, via S&DRT)

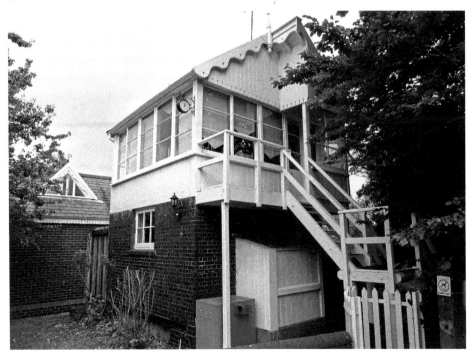

The signalbox at Wellow is the only one that survived in its original location, though now with a new building alongside. It was acquired and restored by artist Peter Blake and remains in good condition.

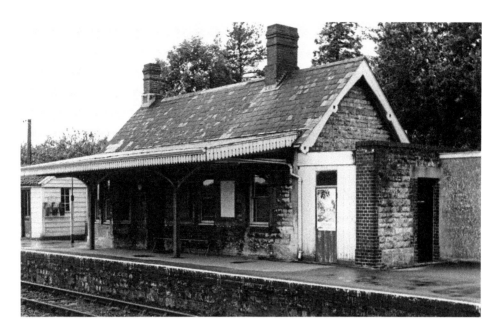

Wellow station building was typical of those on the Bath extension, constructed in grey limestone with a bay-windowed stationmaster's office on the Up platform. It survives as a private residence, the space between the platforms having been filled to provide a lawn. (John Eyers, South Western Circle, Eyers Collection, via S&DRT)

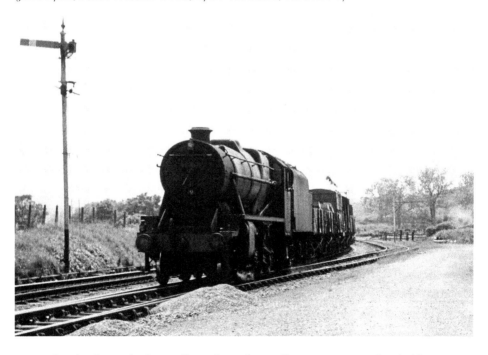

An Up freight alongside the small goods yard at Wellow in June 1962, headed by 8F 2-8-0 No. 48468, then of Bath Green Park shed; this locomotive survived two years longer than the S&D, into the last year of BR steam. The yard at Wellow closed in June 1963 and the sidings were removed a year later. (David Milton, S&DRT)

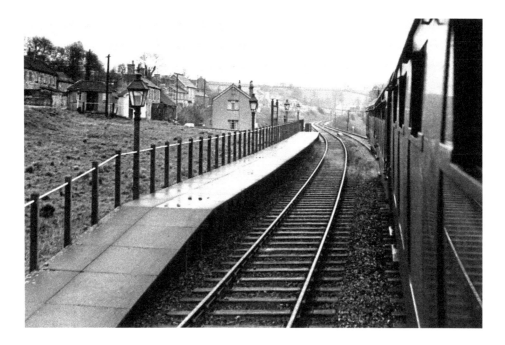

Shoscombe & Single Hill Halt seen from the carriage of a Down train. It was opened amid much celebration on 23 September 1929 by George Lansbury MP. The small ticket office and shelter on the footpath to the village was staffed throughout by the Misses Tapper, later Mrs Beeho and Mrs Chivers. (John Eyers, South Western Circle, Eyers Collection, via S&DRT)

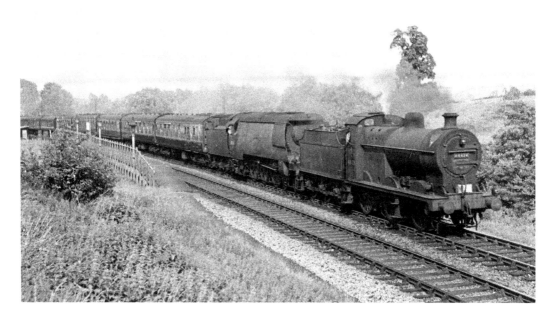

A classic S&D locomotive combination heads the down Pines Express through Shoscombe & Single Hill Halt on 22 August 1959. Bristol Barrow Road shed's Fowler 4F 0-6-0 No. 44424 pilots Bournemouth's West Country No. 34041 *Wilton*. (Anon, S&DRT)

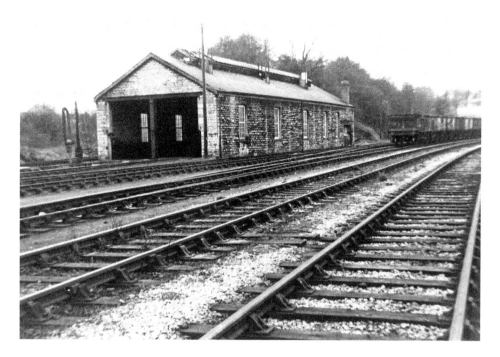

Radstock's solid-looking stone-built engine shed was located east of the station. It was the first home of the Somerset & Dorset Railway Circle's locomotives and rolling stock from 1970, but its two roads appeared empty and bereft of activity the previous year.

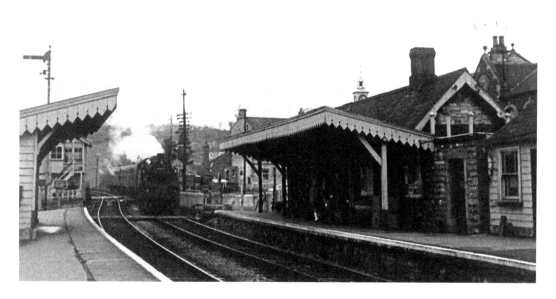

An Up train headed by BR 4MT Class 2-6-4T No. 80081 arrives at Radstock North. The town's S&D and GWR stations were next to each other and their two level crossings caused considerable traffic chaos. As early as 1875, the Board of Trade pressed for their replacement with bridges.

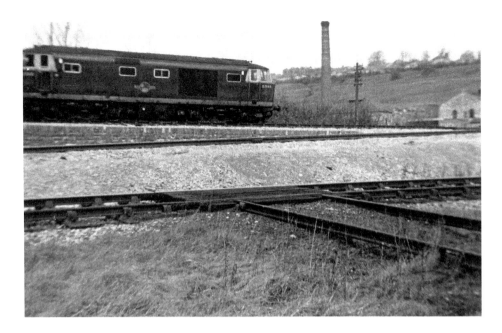

On closure of the S&D, a connection between it and the former GWR line was created west of the two stations at Radstock by slewing the Down S&D line to join the Bristol and North Somerset line, seen in the foreground of this April 1968 view. The Hymek diesel hydraulic, No. D7044, is on the up S&D line from Midsomer Norton.

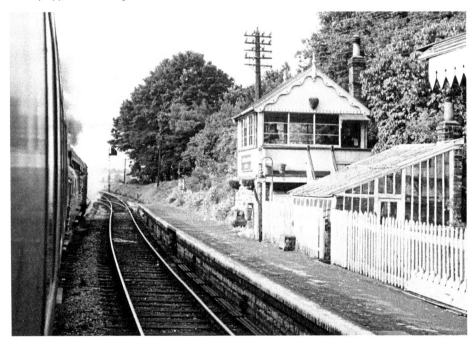

The S&D Joint Committee introduced an annual award for the best-kept gardens in 1913. Midsomer Norton station was awarded the first prize in this year and again no less than twenty-one times up to 1939, presumably aided by the greenhouse erected circa 1885 next to the signalbox, seen here from a Down train in the 1960s. (Bernard Holbrow, S&DRT)

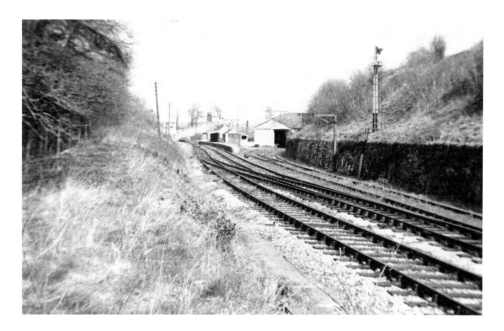

Two years after closure, Midsomer Norton station and its environs seemed remarkably intact, as seen from the south in April 1968. The remains of Norton Hill colliery can be seen above and beyond the station. A quarter of a century after closure, the station building and goods shed were being used as an annexe to Norton Radstock College.

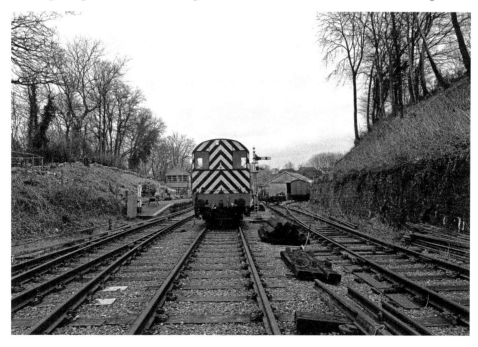

In 1996 the Somerset & Dorset Railway Heritage Trust took over Midsomer Norton station with the aim of restoring it to its 1950s condition. The station building and goods shed have been restored, the signalbox and greenhouse rebuilt from surviving foundations, and the stables refurbished to accommodate a museum. (Kate McStraw)

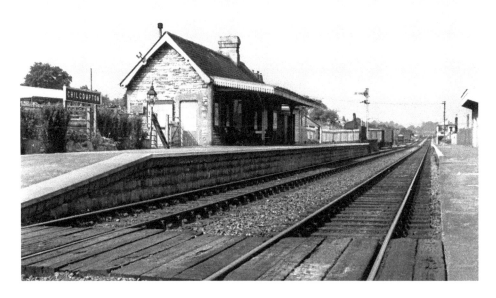

Chilcompton station, looking down, i.e. towards Binegar, from the barrow crossing at the end of the platforms. The up platform, right, was twice as long as the Down and spanned the cattle creep (bridge No. 53). The signalbox was at the western end of the Up platform, opposite the small goods yard. (Anon, South Western Circle, Eyers Collection, via S&DRT)

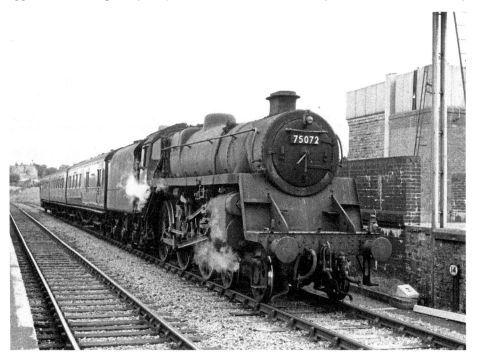

A Down local passenger train headed by BR 4MT 4-6-0 No. 75072 stands at Chilcompton station on 7 August 1961. The large water tower was used by banking engines returning to Radstock from Masbury. (David Milton, S&DRT)

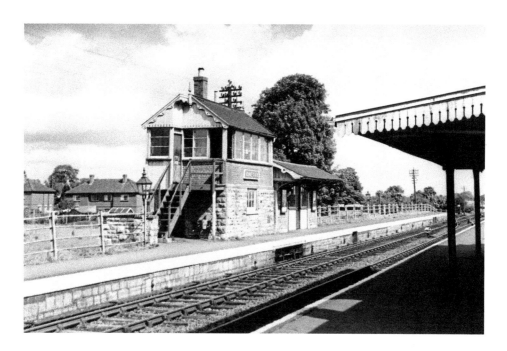

The signalbox and station at Binegar featured in the BTF (British Transport Film) staff training film *Single Line Working* of 1956, which continued to be used by BR until the late 1970s. In an attempt to disguise the location of the film, Binegar was renamed 'Boiland'. (John Eyers, South Western Circle, Eyers Collection, via S&DRT)

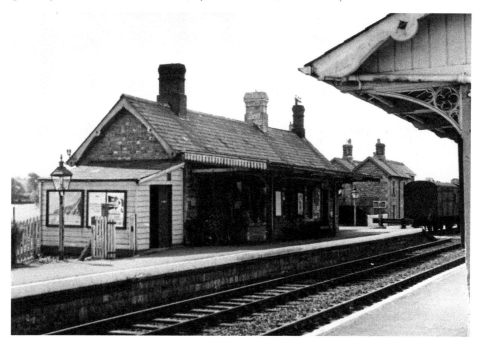

The station building at Binegar was on the Down platform, to the right of which can be seen the stationmaster's and signalman's houses. Beyond these, the goods yard included sidings serving two cattle pens. (John Eyers, South Western Circle, Eyers Collection, via S&DRT)

The large stone-built goods shed was owned by the Oakhill Brewery until 1921 and was served by their narrow gauge railway. It is seen here in March 1991, when it still housed a 1-ton hand crane, later rescued by the S&DRT.

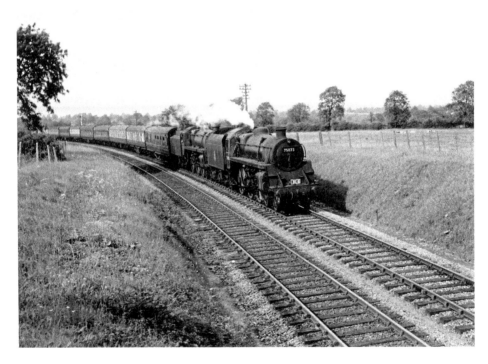

The 3.55 p.m. ex-Bath reaches Masbury summit on 3 August 1957, headed by BR 4MT 4-6-0 No. 75073 piloting BR 5MT 4-6-0 No. 73051. (John Woods, S&DRT)

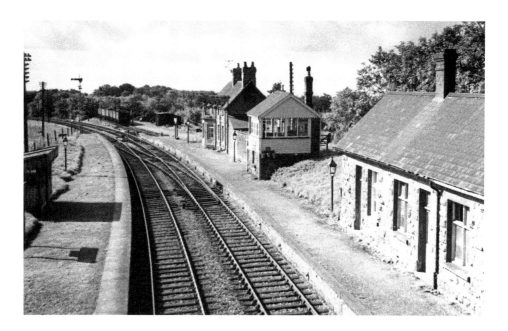

The station building at Masbury was in a different style to others on the Bath extension, having a booking office and waiting room only and no awning. The station became an unstaffed halt from 26 September 1938, the substantial station house being latterly occupied by the relief Evercreech Junction stationmaster. (John Eyers, South Western Circle, Eyers Collection, via S&DRT)

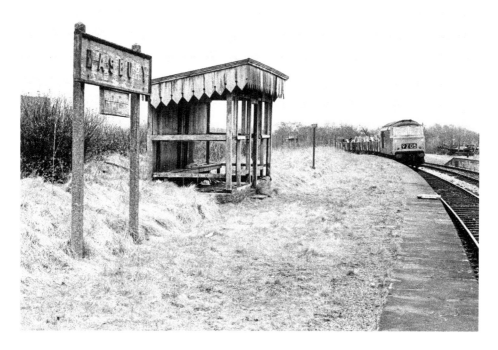

Salvage contractors W. H. Arnott, Young & Co. of Bilston, Staffordshire, began dismantling the line between Bath and Shillingstone in December 1966. A Hymek diesel hydraulic stands in Masbury's Down platform with a post-closure demolition train. (Robin Atthill, S&DRT)

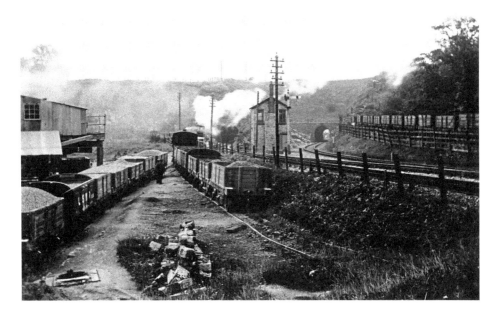

This view at the north of the Winsor Hill tunnels (bridge No. 77) shows the original bore of 1874 on the left and the later Up bore of 1892, right. The sidings on the left served Winsor Hill quarry from 1875 to 1957, those on the right Hamwood Quarry from 1893 until the early 1960s. The signalbox opened in 1892, replacing an earlier one, and was the only one on the line built entirely in stone; it closed in 1948. The photograph dates from around 1893. (Thomas Maidment, S&DRT)

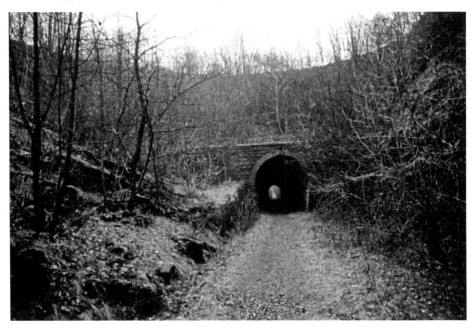

The original bore of Winsor Hill tunnel was 242 yards (221 m) long. Unlike at Devonshire and Combe Down tunnels, it was possible to double the tracks at Winsor Hill by creating a new, shorter bore of 132 yards (120 m), seen here from the north in March 1991.

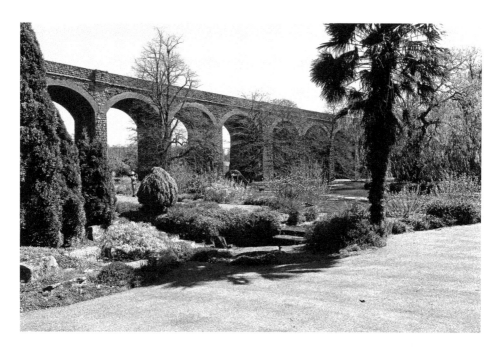

The 317 yards (290 m) and twenty-seven arches of Charlton Viaduct stride 67 feet (20 m) above the gardens of Kilver Court Designer Village, Shepton Mallet. Francis Showering of Babycham fame had the gardens created in 1961, based on an award-winning design at Chelsea Flower Show. (Kate McStraw)

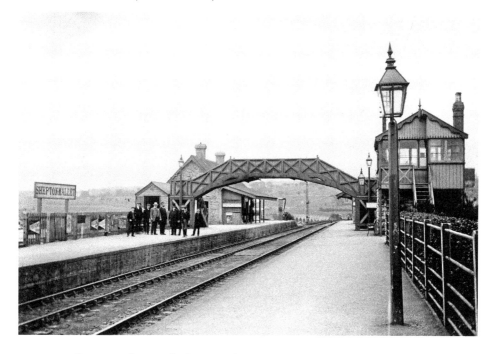

Station staff pose on the Up platform at Shepton Mallet station c. 1895–1900, shortly after the doubling of the line. Charlton Viaduct can be seen in the distance, beyond the original wooden footbridge. (Thomas Maidment, S&DRT)

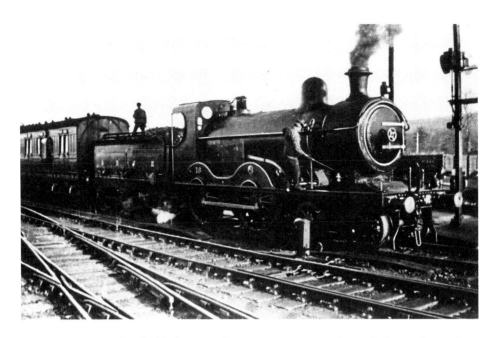

The MR constructed eight 'A' Class 4-4-0 locomotives to S. W. Johnson's design for working express traffic between Bath and Bournemouth; the first four were built in 1891. One of the first batch, No. 16, is seen taking water at Shepton Mallet with the driver oiling behind the smokebox. It is seen in its rebuilt form with larger boiler; the engine was withdrawn in 1928. (Anon, S&DRT)

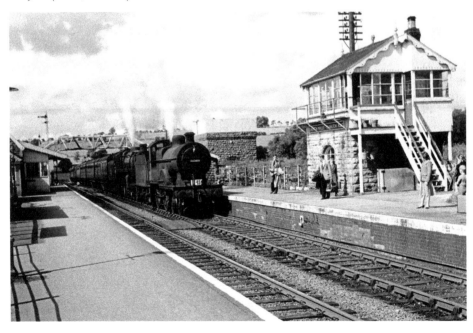

A southbound express arrives at Shepton Mallet Charlton Road on 2 August 1958, headed by 2P 4-4-0 No. 40568 piloting BR 5MT 4-6-0 No. 73047. Shepton Mallet also featured in the BTF training film *Single Line Working*, for which it was renamed 'Averton Hammer'. (John Woods, S&DRT)

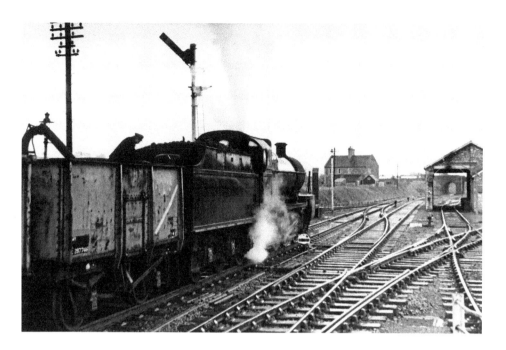

Taking water at the south end of Shepton Mallet's Down platform, S&DJR 7F Class 2-8-0 No. 53810 prepares to leave with a freight train. The bridge carrying the GWR over the S&D can be seen through the goods shed, right. (John Eyers, South Western Circle, Eyers Collection, via S&DRT)

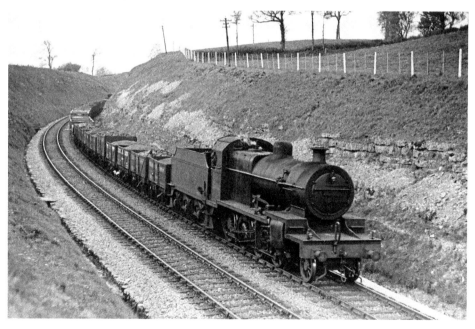

One of the first batch of 7F 2-8-0 locomotives, seen here in LM&SR days as No. 13801 (originally S&D No. 81, later LMS No. 9671), heads a mineral train south of Shepton Mallet through Cannards Grave cutting. (Anon, South Western Circle, Eyers Collection, via S&DRT)

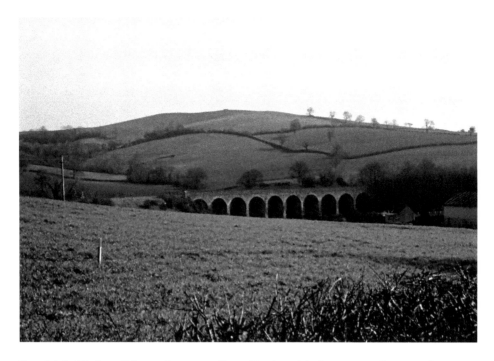

Prestleigh Viaduct did not fare so well as Charlton Viaduct as its eleven arches were considered structurally unsound after years of neglect and it was destroyed by explosives on 16 January 1993.

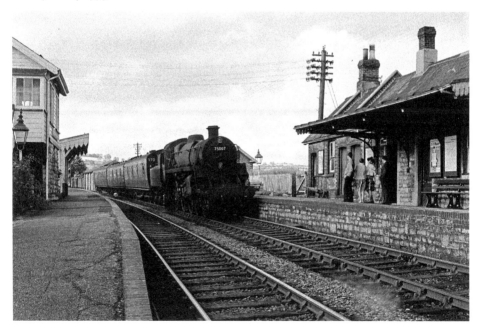

Evercreech New station opened on 20 July 1874 with the Bath extension and was more conveniently located for the village than the original SCR station. A Down train arrives behind BR 4MT 4-6-0 No. 75007. Note the station building's distinctive roof line, the horseshoe above the porter's room and an ex-GWR platform seat. (Ted Salthouse)

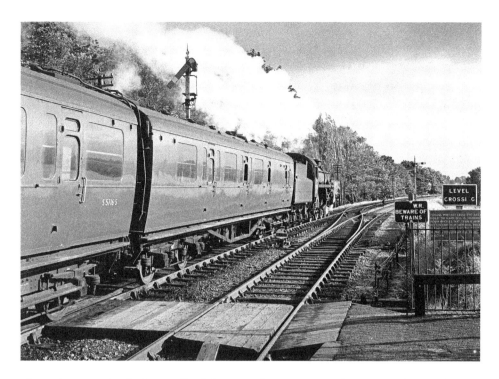

The train, comprised of SR Bulleid three-coach set No. 970, departs south over the foot crossing behind No. 75007. Evercreech New generated considerable milk traffic as well as lime from Evercreech Lime & Stone's substantial kiln next to the station. (Ted Salthouse)

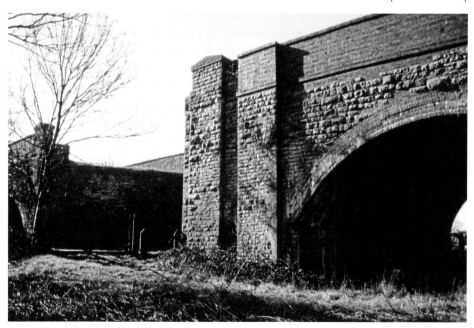

The remains of Pecking Mill Viaduct, south of Evercreech New, looking north from beside the A371 road in March 1991. Tree growth in the subsequent twenty-five years has almost completely obscured the bridge.

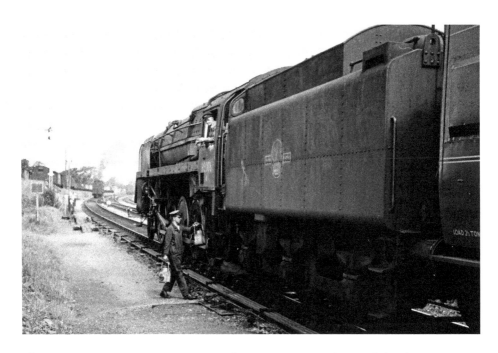

The Up Pines Express waits at Evercreech Junction on 31 July 1961 behind 9F 2-10-0 No. 92006, which was transferred to the S&D for the summer months. The fireman removes the headlamps as S&DJR 2P Class 4-4-0 No. 40634 (original No. 45) prepares to back on as pilot engine. (David Milton, S&DRT)

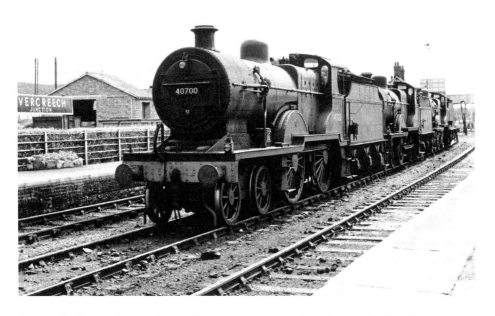

A trio of 2P 4-4-0 locomotives wait in the centre road at Evercreech Junction to assist northbound trains over the Mendip hills; they are Nos 40700, 40564 and 40697. The photograph is recorded as taken at 11.45 a.m. on Saturday 2 August 1958. (John Woods, S&DRT)

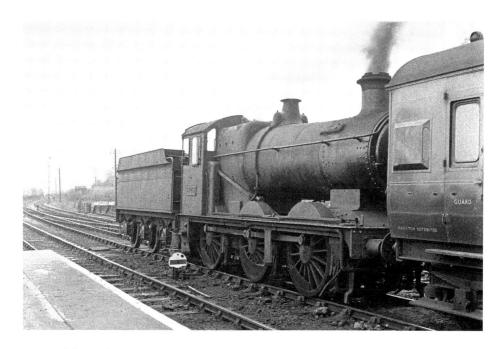

The middle road at Evercreech Junction was also used by branch trains between trips. Collett 0-6-0 No. 3206 stands with its train c. 1963. The class was first allocated to Templecombe in 1960 to replace MR 3F and 4F 0-6-0 and 2P 4-4-0 locomotives as they were withdrawn. (Ted Salthouse)

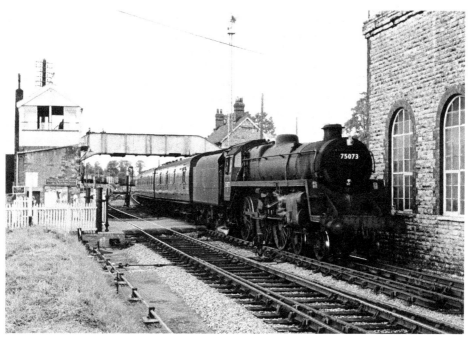

The 1.10 p.m. Bath Green Park to Templecombe local train leaves Evercreech Junction on 4 August 1962, behind BR 4MT 4-6-0 No. 75073. The twenty-six-lever South signalbox controlled the level crossing over the A371 road. (John Woods, S&DRT)

The original SCR station building was rebuilt and enlarged as the stationmaster's house and survives along with the later station building, also on the Down platform. They are seen here in March 1991, the former stationmaster's house at the time renamed 'Sdoog Dray'.

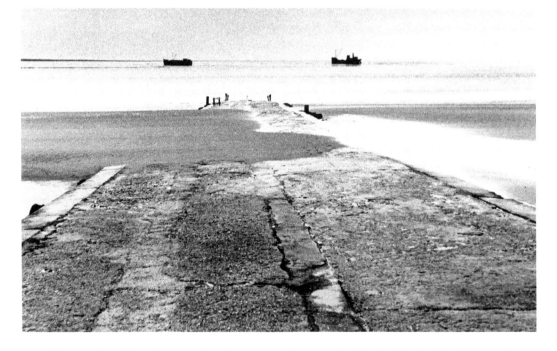

The remains of the slipway at Burnham-on-Sea face towards shipping in the Bristol Channel in the 1960s. The hopes of the SCR that this would facilitate a profitable coast-to-coast service proved to be false. (John Eyers, South Western Circle, Eyers Collection, via S&DRT)

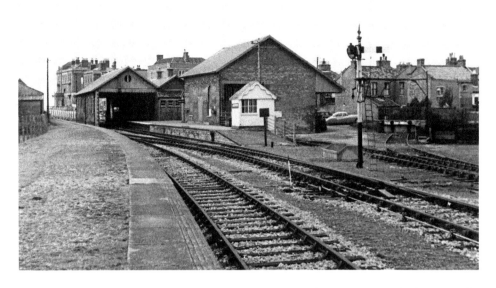

The station at Burnham-on-Sea looking west from the excursion platform in the 1960s, showing the short overall roof and station building beyond the goods shed. The light-painted building in front of the goods shed was the signal, which is now preserved by the S&DRT at Washford on the West Somerset Railway. (John Eyers, South Western Circle, Eyers Collection, via S&DRT)

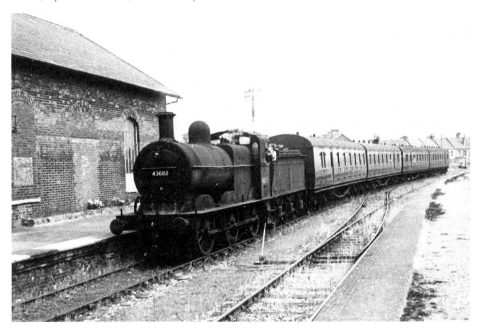

Arriving at Burnham-on-Sea with a four-coach train on 24 June 1961 is Johnson 3F 0-6-0 No. 43682. Opened by the SCR in 1858, Burnham was the western terminus of the main line until the Bath extension opened in 1874. (Anon, S&DRT)

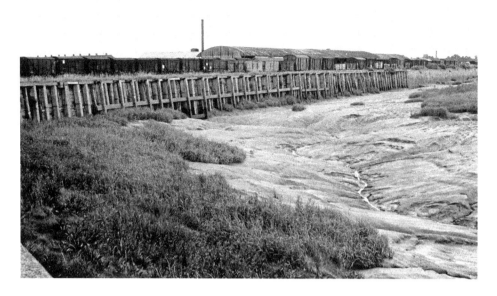

Highbridge Wharf looking east from the western end of the docks, seen during the early 1960s. Until 1932 thousands of tons of rails were shipped from South Wales for use on the S&D and the SR, after which they were brought by railway via the Severn Tunnel. (David Milton, S&DRT)

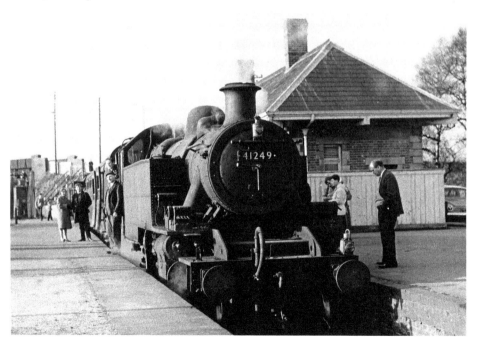

The last service train on the branch was the 4.00 p.m. passenger from Highbridge on 5 March 1966. It is seen here waiting in the bay between platforms 2 and 3 behind Ivatt 2-6-2T No. 41249, carrying S&D headcode lamps. (David Milton, S&DRT)

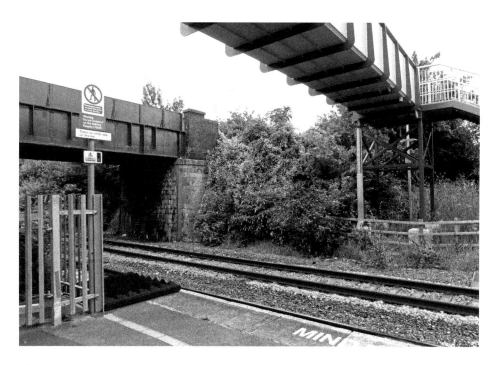

The former GWR station at Highbridge remains open on the Bristol to Taunton line. The S&D crossed the GWR line diagonally under the road bridge, seen left in 2015. The steel footbridge replaced an earlier concrete one which was further south and spanned both GWR and S&D lines.

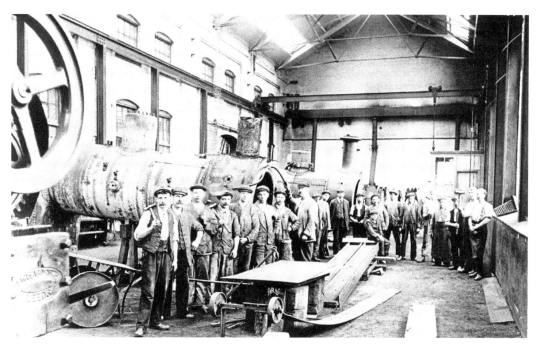

An interior view of the S&D works at Highbridge *c.* 1895, with twenty workers posing in front of locomotive boilers in the boiler shop. (Anon via Robin Atthill, S&DRT)

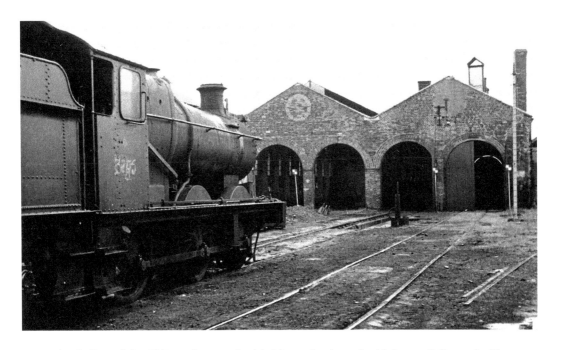

The decline of the S&D can be seen in this May 1965 view of withdrawn Collett 0-6-0 No. 3205 outside Highbridge engine shed. The engine was purchased for preservation and hauled the re-opening train on the Severn Valley Railway in 1970. (Anon, S&DRT)

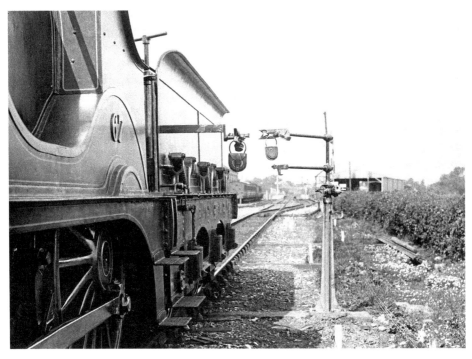

The patent Whitaker tablet exchanger is seen here attached to the tender of Johnson 'A' Class 4-4-0 No. 67 built 1896, during a demonstration of the apparatus at Highbridge *c.* 1900. (Thomas Maidment, S&DRT)

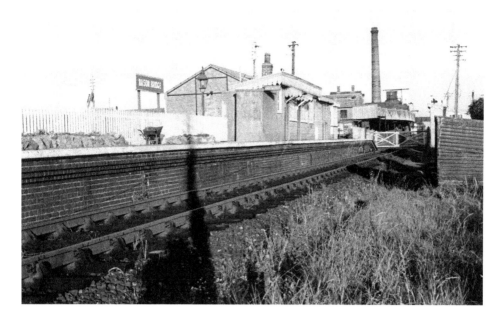

Bason Bridge station, seen from the west with the level crossing and the milk factory beyond. The proximity of the River Brue south of the line caused problems when the factory sidings were extended in the 1930s. (Anon, South Western Circle, Eyers Collection, via S&DRT)

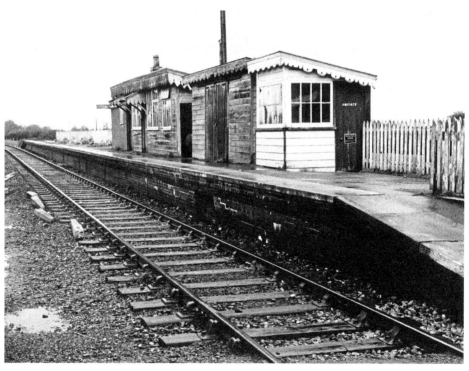

A post-closure view of Bason Bridge station shows the simple wooden buildings intact but dilapidated. The station had opened in July 1856, two years after the line. (Anon, S&DRT)

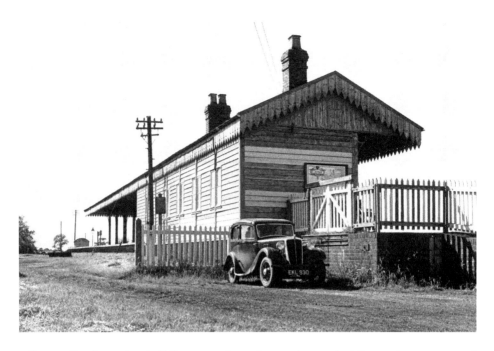

Edington Burtle station building, seen from the south *c.* 1960. The station was named Edington Road until the Bridgwater Railway opened on 21 July 1890, when it became Edington Junction. The platform face on the left served trains to Bridgwater until closure to passengers on 1 December 1952, after which the station was once again renamed. (David Milton, S&DRT)

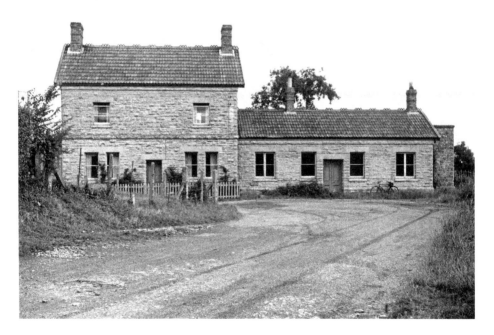

The solid stone-built station building and adjacent stationmaster's house at Cossington, seen from the station approach *c.* 1960. The buildings remain in use as private residences. (David Milton, S&DRT)

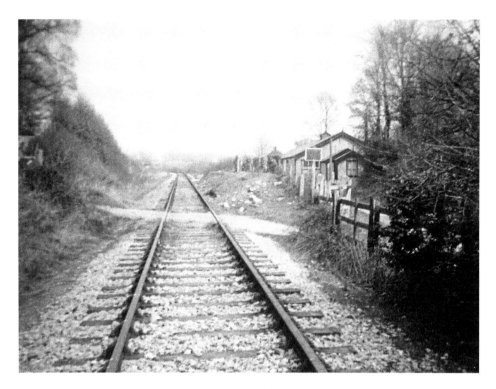

Bawdrip Halt was opened by the L&SWR on 7 July 1923 in response to a petition from residents. It had dealt with over 2,000 passengers by the end of September, but they were not provided with a shelter until the following year. This 1954 view shows the demolished platform with the parish hall behind. (Anon, S&DRT)

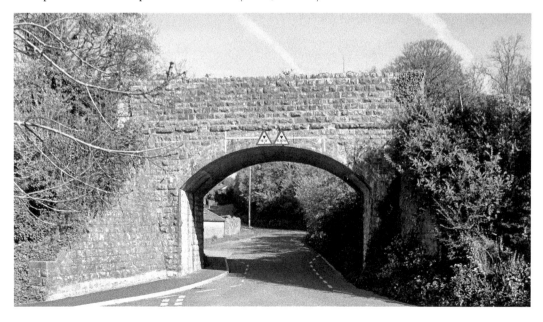

Bawdrip Bridge, which carried the railway over the road to the village, is in good condition and maintained by owners the Highways Agency Historical Railways Estate. (Dave Brown)

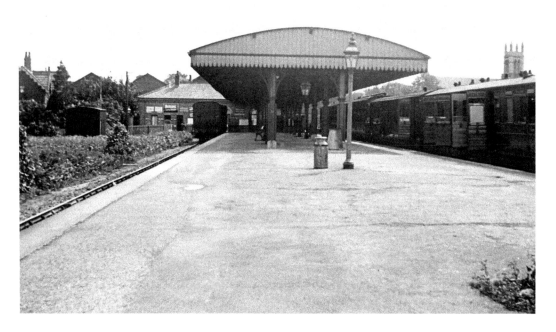

Bridgwater station comprised an island platform with an awning covering around two-thirds of its length. This early view looks south towards the buffer stops and station building beyond. A yard with goods shed and single-road engine shed with turntable were provided west of the station. (Anon, South Western Circle, Eyers Collection, via S&DRT)

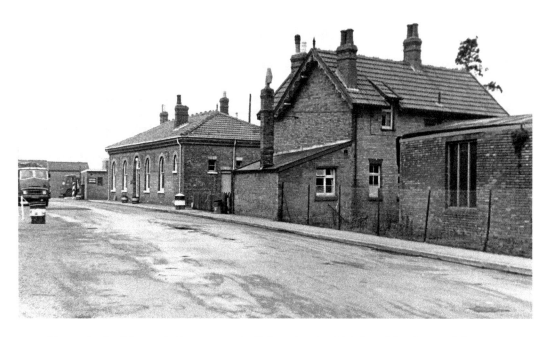

The station building at Bridgwater was built from local red brick and faced toward the town with the stationmaster's house alongside. It was renamed Bridgwater North in September 1949 to distinguish it from the former GWR station. The station building was demolished in August 1984. (John Eyers, South Western Circle, Eyers Collection, via S&DRT)

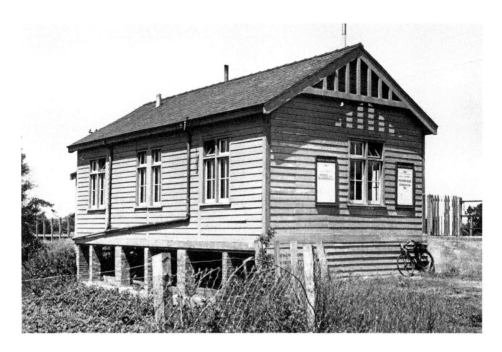

The simple wooden station building at Shapwick, seen from the roadside. The station building was a replacement for that destroyed in September 1900 by a fire that started in the signalbox. (David Milton, S&DRT)

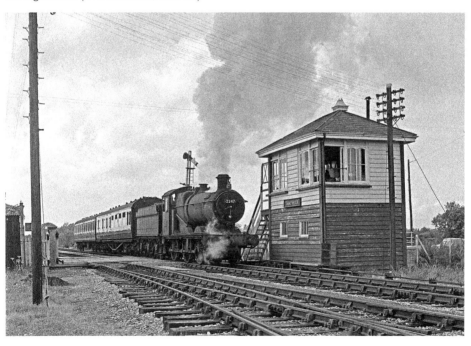

An Up train leaves the long passing loop at Shapwick station and heads past the 1901 signalbox towards Glastonbury behind Collett 0-6-0 No. 2247 in the early 1960s. The seventeen-lever signalbox replaced that burnt down on the other side of the level crossing. (Ted Salthouse)

There were extensive peat works between Shapwick and Ashcott stations where the 2-foot (600 mm) gauge tramway crossed the S&D on the level. This was the site of a collision between a stalled narrow gauge train and a Glastonbury to Bridgwater train in August 1949 which resulted in the S&D engine being broken-up on site. (David Milton, S&DRT)

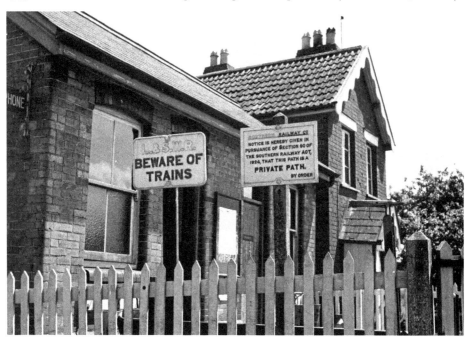

The station building at Ashcott & Meare was at road level behind the single platform. This c. 1960 image shows the waiting room, booking office and station house, viewed from the level crossing. (David Milton, S&DRT)

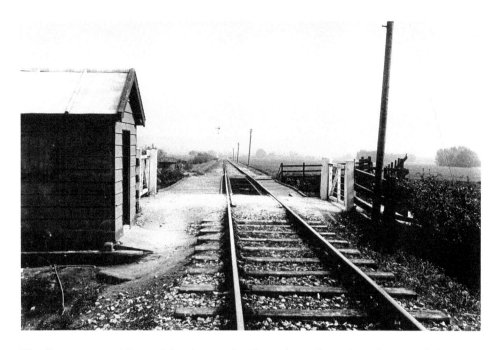

The line runs straight and level towards Glastonbury from Aqueduct Level Crossing, the Tor just visible on the distant horizon. Just beyond the crossing is Aqueduct Bridge, spanning the River Brue. The bridge was rebuilt in August 1903 with wrought iron lattice girders and survives. (Thomas Maidment, S&DRT)

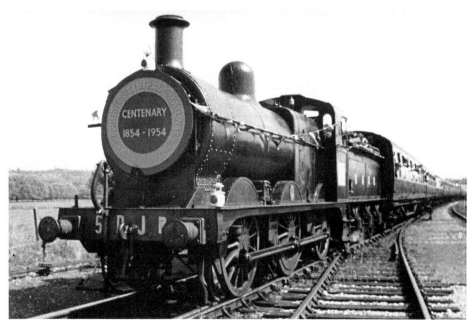

The centenary of the SCR was celebrated by the running of a special train hauled by former Johnson 3F 0-6-0 No. 43201 on 28 August 1954. The locomotive, carrying its original S&D number, 64, on the cabside, is seen with the train at Glastonbury. (David Milton, S&DRT)

This red-brick building was built by Glastonbury solicitor James Rocke in 1861 as The Abbey Arms & Railway Hotel. The SCR leased part as offices and it later became the S&D headquarters until 1876. It survives within the site of Snows Timber Ltd. (David Milton, S&DRT)

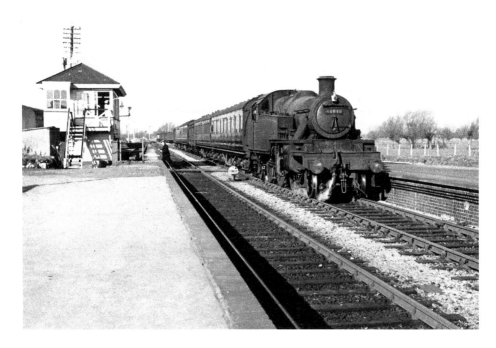

A Down local passenger train arrives at Glastonbury & Street on 8 February 1961 behind Stanier 3MT 2-6-2T No. 40098, which worked on the branch for a short time. The station was renamed Glastonbury & Street in 1886. (David Milton, S&DRT)

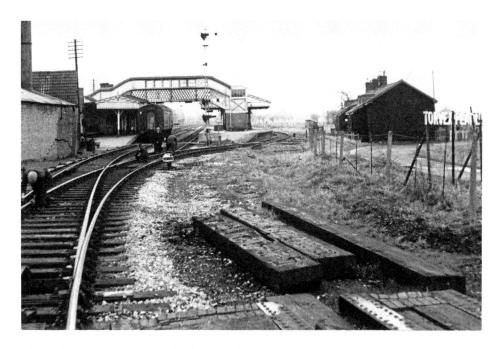

Glastonbury & Street station, looking up from Dye House Lane level crossing. The site of the line to Wells is in the right foreground. The station site was levelled in 1984 but the island platform canopy was relocated to the car park in St John's Square. (John Eyers, South Western Circle, Eyers Collection, via S&DRT)

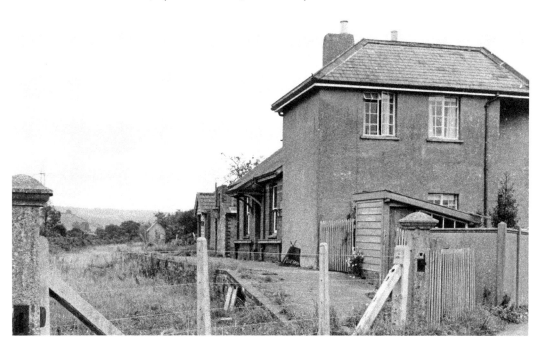

Polsham was the only intermediate station on the line to Wells and opened in December 1861. This post-closure view is taken from the site of the level crossing. The buildings survive in extended form as a private residence. (Anon, S&DRT)

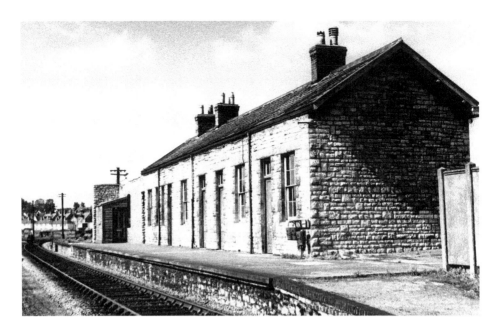

Wells Priory Road station opened on 15 March 1859 and continued in use after the closure of the S&D branch as a goods depot on the former East Somerset line from Shepton Mallet until 13 July 1964. The station's overall roof was removed soon after passenger services ceased. (John Eyers, South Western Circle, Eyers Collection, via S&DRT)

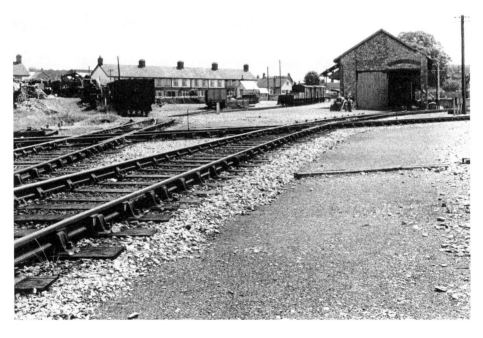

The former S&D goods yard and goods shed at Wells, seen from the west in the 1960s with the houses of West Street beyond. The former GWR line from Wells Tucker Street station can be seen running across the S&D lines from left to right. The former goods office from Wells is now preserved by the S&DRT at Washford. (David Milton, S&DRT)

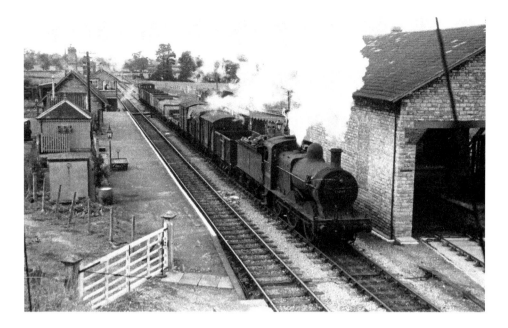

West Pennard station looking from bridge No. 257 with a Down freight train headed by Johnson 3F 0-6-0 No. 43204 (S&D No. 65). This engine class was nicknamed 'Bulldog' on the S&D. The station building and goods shed survive in private ownership. (Anon, South Western Circle, Eyers Collection, via S&DRT)

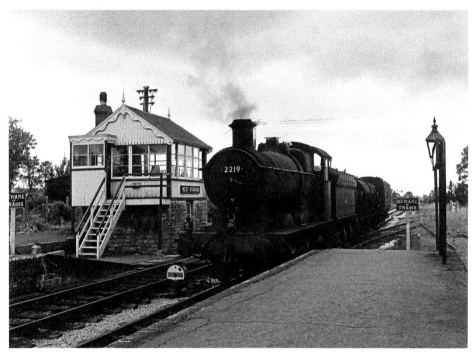

A short milk train arrives at West Pennard's Up platform in the 1960s behind Collett 0-6-0 No. 2219. The engine was withdrawn in 1964, the same year that the twenty-three-lever signalbox closed and the Down loop and sidings were taken out of use. (Ted Salthouse)

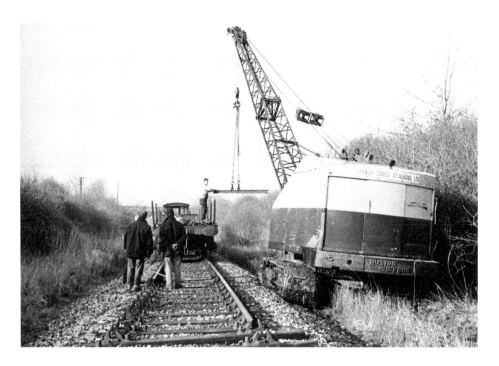

Contractors are busy lifting track near West Pennard with the aid of a tracked Ruston Bucyrus crane. Track lifting on the branch began in 1967. (David Milton, S&DRT)

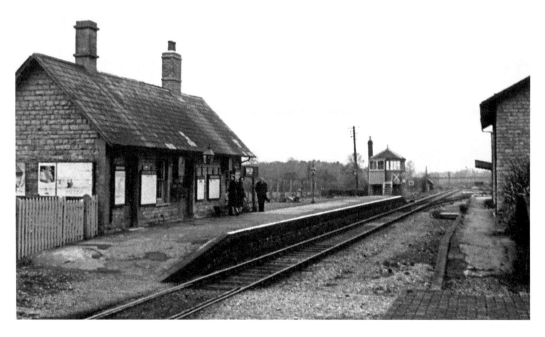

Like West Pennard, Pylle station opened on 3 February 1862 with the SCR extension to Cole. The station building on the Up platform is seen here in March 1953. The signalbox was closed in 1929 but remained in use as a ground frame for the single siding serving the goods shed until this closed in 1963. (Anon, South Western Circle, Eyers Collection, via S&DRT)

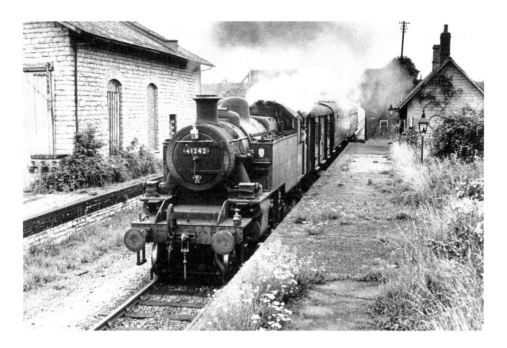

The 4.05 p.m. Templecombe to Highbridge local passenger train running into Pylle station with Ivatt 2-6-2T No. 41242 in charge in July 1963. The Down loop was taken out of use in 1929 and the station became an unstaffed halt in November 1957. An unusual feature was the stationmaster's house being attached to the further end of the goods shed. (Anon, S&DRT)

Evidence of the railway twenty-five years after closure in the shape of the former Field Lane occupation crossing south of Evercreech Junction, complete with wicket gate.

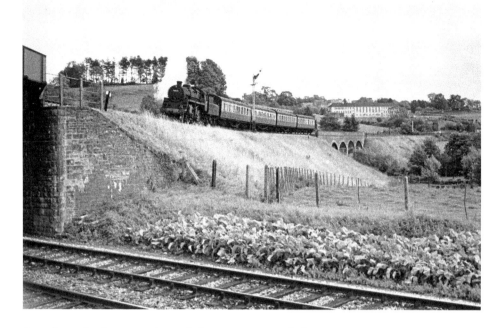

Seen from the former Wilts., Salisbury & Weymouth line, near the site of the proposed connection with the SCR, an Up semi-fast passenger train is headed by BR 4MT 2-6-0 No. 76026 in the summer of 1957. The train has just crossed Cole Viaduct and is about cross the Great Wester Bridge. Cole Viaduct was demolished in September 1984. (David Milton, S&DRT)

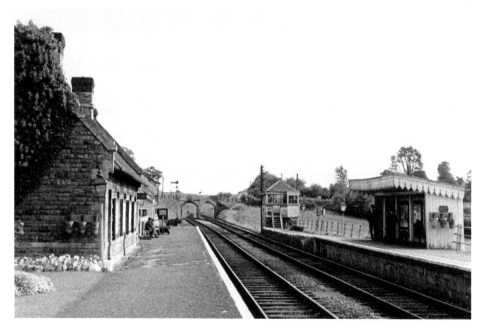

Looking down towards Wincanton from Cole station, towards Pitcombe Road Bridge in September 1962. The station building and store can be seen to the left, and the signalbox and shelter on the Up platform, right. (John Eyers, South Western Circle, Eyers Collection, via S&DRT)

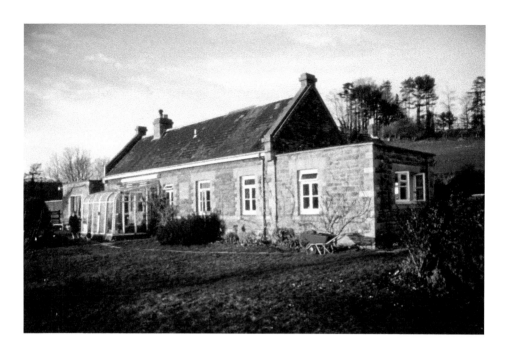

The stone-built station building at Cole was of typical DCR design, with high gables and tall chimneys. It was converted to a private residence in 1977, as seen here in March 1991; the glazed conservatory has been replaced in recent years with an extension more in keeping with the building.

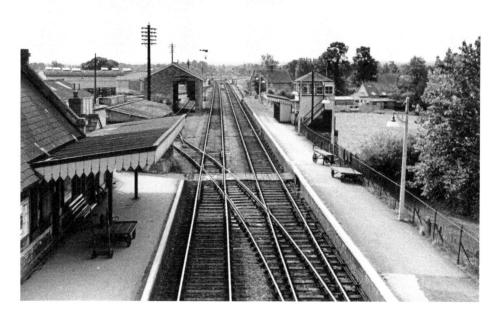

Wincanton station, seen from the footbridge looking south towards Templecombe in September 1961. In 1933 agreement was reached with Cow & Gate for a siding at Wincanton in connection with the extension to their works. (John Eyers, South Western Circle, Eyers Collection, via S&DRT)

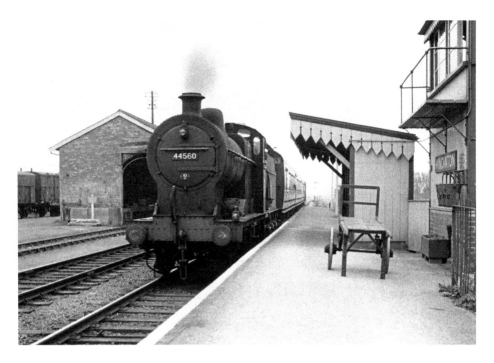

A local passenger train arrives at Wincanton's longer Up platform on 2 June 1962 with Templecombe's Fowler 4F 0-6-0 No. 44560 in charge. The goods shed housed a 30 cwt hand crane. (David Milton, S&DRT)

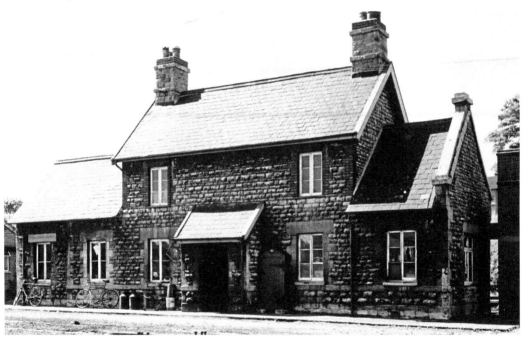

The former DCR station buildings at Templecombe were later incorporated into the motive power depot. As seen here in August 1965, the facilities comprised stores, lobby, clerk's office and shed office. (David Milton, S&DRT)

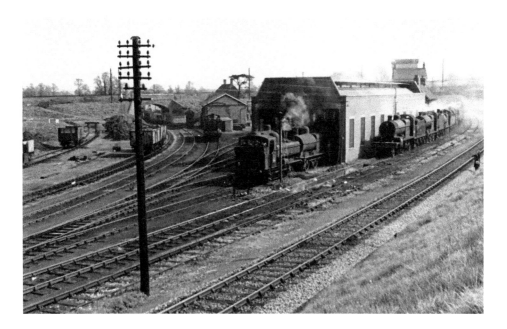

Western Region influence is evident in the shape of a GWR 0-6-0 pannier tank at Templecombe motive power depot, seen from the spur to the upper station in April 1959. The original connecting spur to the L&SWR remained in use as a siding and runs left of the goods shed under Combe Throop Lane Bridge. (John Eyers, South Western Circle, Eyers Collection, via S&DRT)

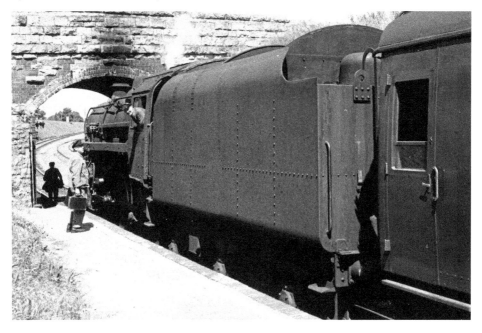

Templecombe Lower platform was opened in 1880 and remained in use for some passenger trains and for locomotive crew changes, as seen here. BR 4MT Class 2-6-0 No. 76057 is about to leave with a non-stop Bournemouth to Bath passenger train and pass under Throop Lane Bridge in 1965. (David Milton, S&DRT)

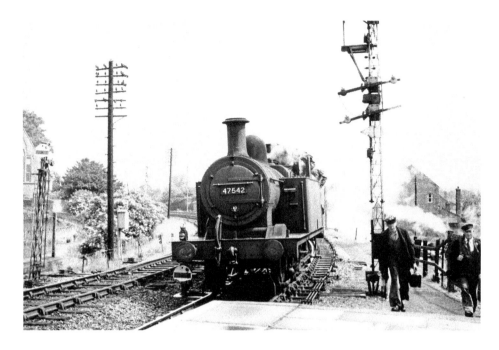

Arriving at the top of the spur to Templecombe Upper station on 9 June 1960 is pilot engine 3F 0-6-0T No. 47542. The locomotive will draw a Down train back down the spur beyond the junction for it to continue its southbound journey. (David Milton, S&DRT)

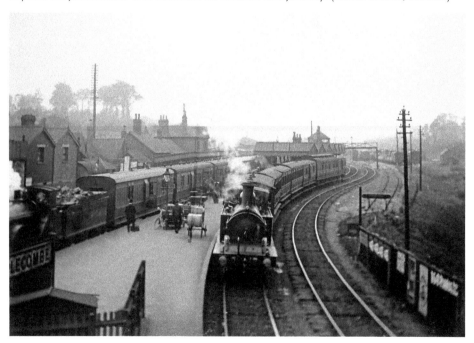

A late nineteenth-century view of Templecombe Upper station, looking west with an S&DJR train on the right headed by an Avonside 0-4-4T locomotive. The train is comprised mostly of six-wheel S&DJR stock, dwarfed by the MR clerestory coach towards the rear. The station was extensively rebuilt by the SR in 1938. (Thomas Maidment, S&DRT)

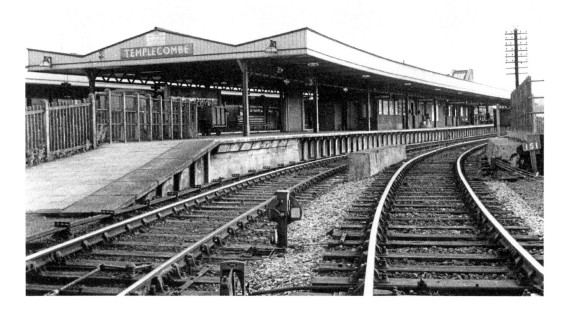

A view of Templecombe station's No. 3 platform, as used by S&D trains, looking west. A proposal in the early 1900s to build a new joint station east of the S&D line, which would have connected it via a second loop to the line south and allowed through running, was not pursued as the cost outweighed the perceived benefits. (Anon, S&DRT)

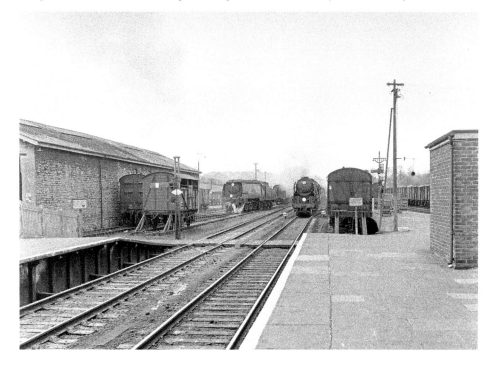

The west end of the island platform at Templecombe, looking towards Yeovil, with SR Bulleid Pacific locomotives in original and rebuilt condition in evidence. The goods shed on the left survives in non-railway use, although it was vacant in 2015. (Ted Salthouse)

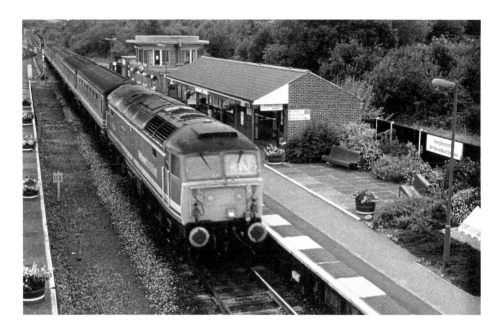

Templecombe station was closed completely at the same time as the S&D, but after a local campaign was finally re-opened on 3 October 1983. The signalbox was at first adapted so that the upper floor doubled as a waiting room and booking office. A London-bound train arrives at the only remaining platform behind station namesake Class 47 diesel electric No. 47708 *Templecombe* on 5 September 1992.

Further changes at Templecombe station in 2012 have resulted in the disused Down platform on the south side, where there is level access to the car park and road, being extended out across the disused trackbed to the remaining line. A South West Trains Class 159 Sprinter diesel multiple unit forms an east-bound train on 30 July 2014.

South of Templecombe at Yenston, the Gartell Light Railway opened to the public in 1991, running trains on 2-foot (610 mm) narrow gauge tracks partly on the route of the S&D. The privately owned railway runs steam and diesel trains for around three-quarters of a mile (1.2 km). (Kate McStraw)

The line south from Templecombe was single-track to Blandford and ran almost straight as far as Stalbridge. Henstridge was the smallest station on the S&D, its platform only some 150 feet (45.7 m) long. The station buildings are seen in their entirety in this September 1965 view looking towards Stalbridge. (John Eyers, South Western Circle, Eyers Collection, via S&DRT)

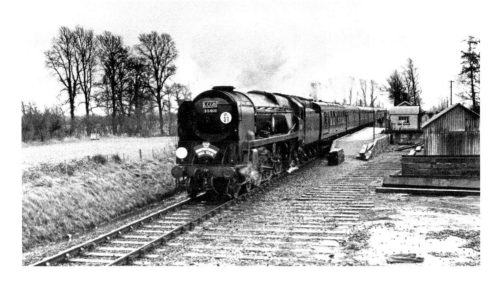

The LCGB rail tour of 1 January 1966 was intended to coincide with closure of the S&D, but this was postponed for three months. The train was hauled by Merchant Navy No. 35011 *General Steam Navigation*, a class normally banned from the line. Seen heading towards Templecombe, The Mendip Merchantman Rail Tour is passing Henstridge station and its former milk dock, to the right. (Anon, S&DRT)

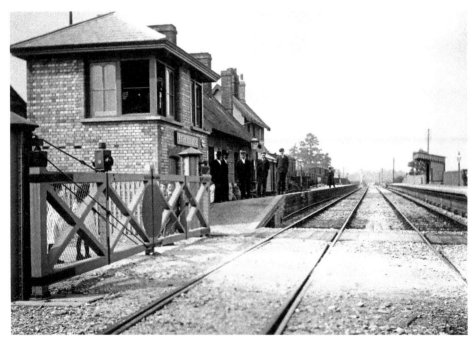

An early view of Stalbridge station looking towards Henstridge from the level crossing. Station staff and officials pose for the photographer on the Up platform alongside the signalbox, station building and station house. A linesman's board (black cross on white oval) is displayed by the signalbox nameplate to indicate that the instruments were functioning correctly. (Thomas Maidment, S&DRT)

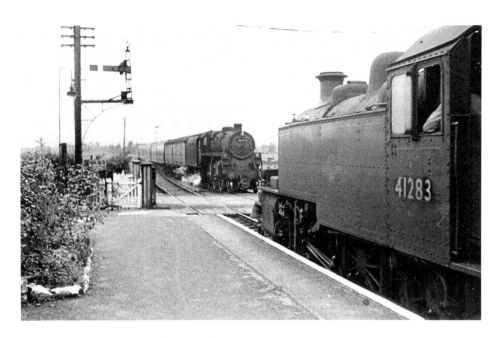

Looking south at Stalbridge towards Sturminster Newton, Ivatt 2-6-2T No. 41283 is waiting at the Down platform as BR 4MT 2-6-0 No. 76057 enters the long loop with an Up stopping train for Bath. (Anon, S&DRT)

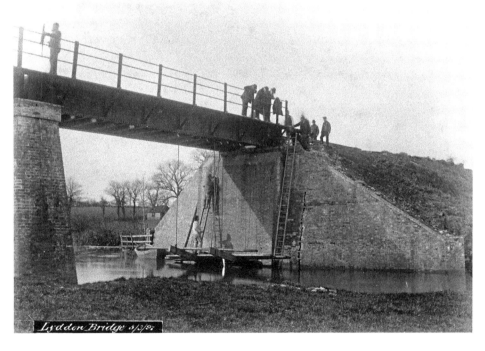

The bridge over the River Lyddon between Stalbridge and Sturminster Newton is being inspected for a crack in the right-hand abutment. The photograph is from the album of Thomas Maidment, who was a surveyor working in the drawing office at Glastonbury, and was taken on 5 March 1897. (Thomas Maidment, S&DRT)

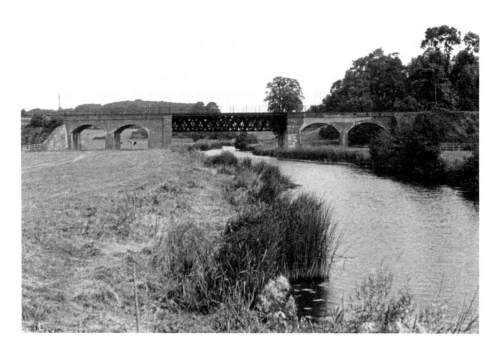

Sturminster Newton River Bridge was one of four crossings of the River Stour within 9 miles (14.4km). The centre span of wrought iron lattice and cross girders has been removed but walkers following the route of the S&D can cross the river to the south via the Colber footbridge. (John Eyers, South Western Circle, Eyers Collection, via S&DRT)

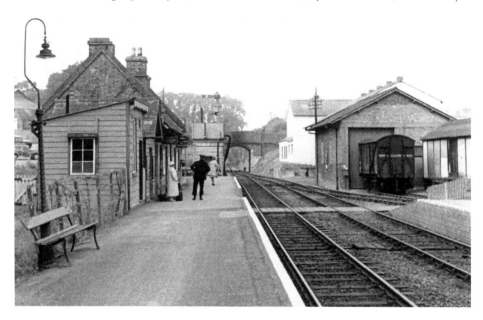

The platforms at Sturminster Newton station were staggered and there was a dip in the Up platform to accommodate the foot crossing, seen in this September 1962 view looking towards Butts Pond Bridge and the line to Stalbridge. Sturminster Newton & District Farmers Ltd requested a siding and loading-stage in 1913 for their new milk and cheese factory alongside the station. (John Eyers, South Western Circle, Eyers Collection, via S&DRT)

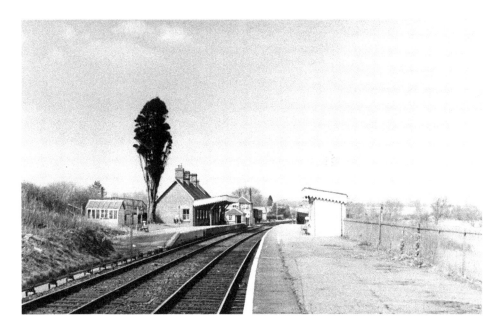

Shillingstone station seen in March 1962, looking up the line from the longer Down platform. The station building was the only one between Templecombe and Blandford with a canopy. Shillingstone was another winner of the annual best kept garden awards; note the stationmaster's greenhouse next to the tall tree. (John Eyers, South Western Circle, Eyers Collection, via S&DRT)

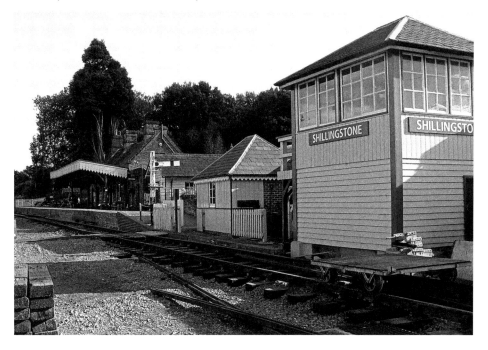

The Shillingstone Railway Project aims to return the station to its early to mid-1950s appearance. Work has included restoring the station buildings and reconstructing the signalbox, seen here in September 2013.

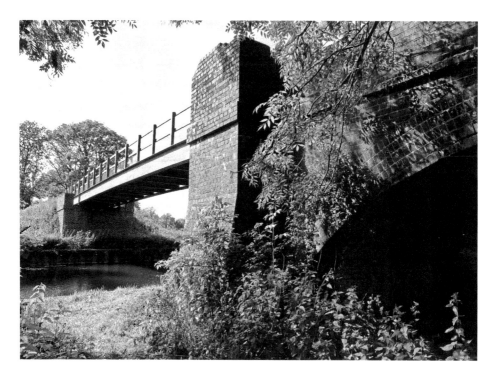

The North Dorset Trailway walking and cycling route runs from Sturminster Newton to Spetisbury and follows the S&D for much of the route. A new bridge was opened on 7 November 2010 to replace the missing wrought iron span of Hodmoor Bridge over the River Stour.

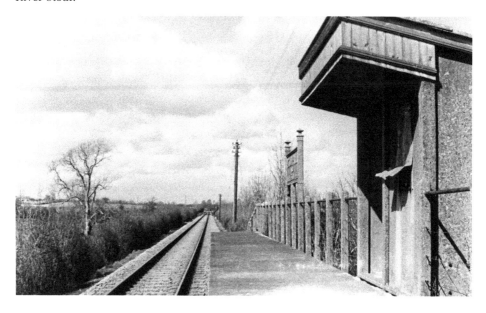

Stourpaine & Durweston Halt was opened in July 1928 and was constructed by the SR using standard concrete components. It closed on 17 September 1956 and survives in a dilapidated condition but is not accessible, the North Dorset Trailway being diverted through Stourpaine village. (John Eyers, South Western Circle, Eyers Collection, via S&DRT)

South of Stourpaine the North Dorset Trailway returns to the S&D trackbed, along which there is still evidence of the railway, including this SR concrete permanent way hut which in June 2015 was disappearing beneath vegetation.

North of Blandford, the North Dorset Trailway crosses the three brick arches of France Farm Drove Bridge. The brick parapet and iron railings of the Down side have been partially revealed after half a century of disappearing back into the landscape.

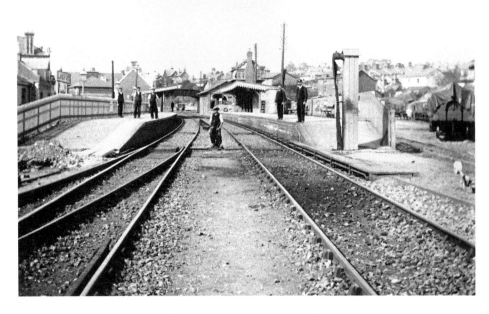

Blandford station seen from the south, *c.* 1900. The signalbox replaced an earlier box on the Up platform and was itself destroyed by fire when struck by lightning on the night of 23 June 1906. The iron footbridge in the background survives but there is little other remaining evidence of the station or goods yard. (Thomas Maidment, S&DRT)

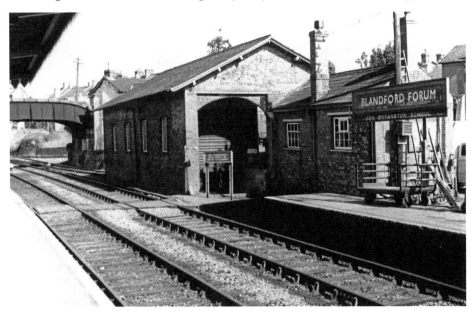

The Forum suffix was not added to the station name until 1953; it is seen here in March 1964. The platforms were served by a subway, the public footbridge being beyond the station. The station remained open for freight until 6 January 1969, when the line from Broadstone was finally closed. (John Eyers, South Western Circle, Eyers Collection, via S&DRT)

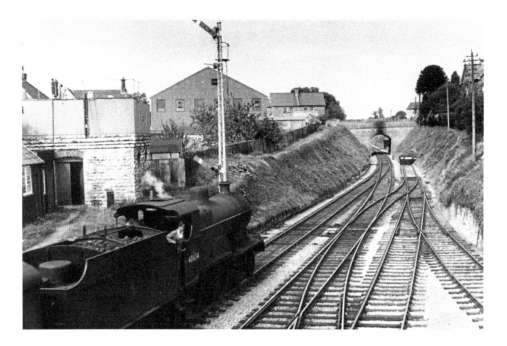

An Up train is leaving Blandford for the single-track section to the north behind 2P 4-4-0 No. 40634 (original S&D No. 45), seen from the footbridge. The base of the water tank, left, survives as a shed; so too does Salisbury Road Bridge beyond. (John Eyers, South Western Circle, Eyers Collection, via S&DRT)

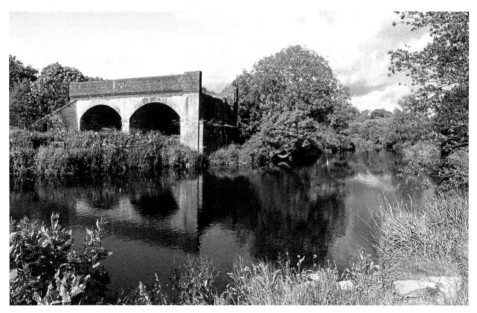

The River Stour Bridge beyond Blandford Forum was the final crossing of the river heading south. The bridge was similar in design to that at Sturminster Newton, with a centre span of wrought iron girders between two pairs of brick flood arches. Only the pair of flood arches on the northern bank remains and is the subject of restoration efforts by BRAT (Blandford Railway Arches Trust).

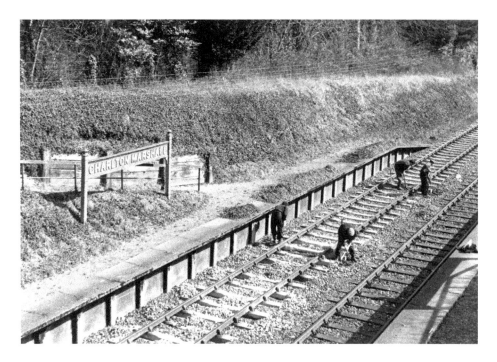

A permanent way gang is seen at work on the Down track at Charlton Marshall Halt in March 1963. The very basic halt opened on 5 July 1928 but, like Stourpaine & Durweston Halt, closed twenty-eight years later. (John Eyers, South Western Circle, Eyers Collection, via S&DRT)

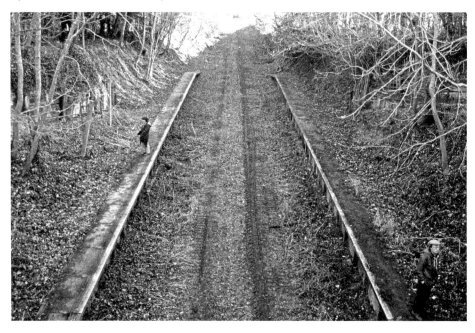

The SR concrete platforms at Charlton Marshall Halt remain, as seen from the road bridge from which the halt was accessed in March 1991. The vehicle tracks were from the installation of a water main along the trackbed along which the North Dorset Trailway runs.

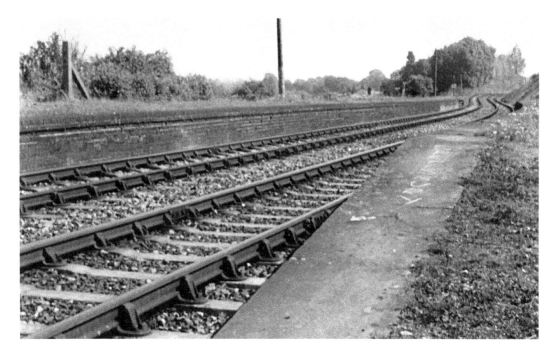

Spetisbury station also closed in 1956 with Charlton Marshall Halt but had a rather longer existence, having opened on 1 November 1860, though it downgraded to an unstaffed halt on 13 August 1934. The station originally had a signalbox that closed in 1952. (Anon, South Western Circle, Eyers Collection, via S&DRT)

The platforms of Spetisbury Halt have almost disappeared into the surrounding environment in this March 1991 view, nearly thirty-five years after it closed. Access to the Up platform was via steep steps from the road below alongside the underbridge.

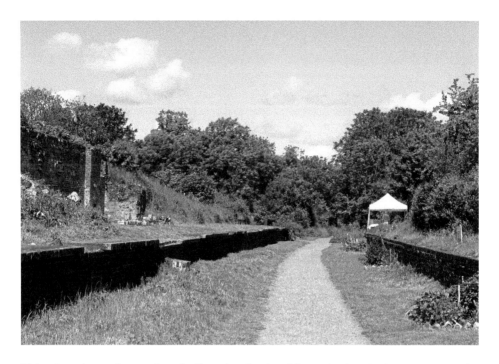

This view shows the results of efforts by the Spetisbury Station Project to restore the station which have revealed the remaining structure of the building on the Up platform. (Kevin Mitchell)

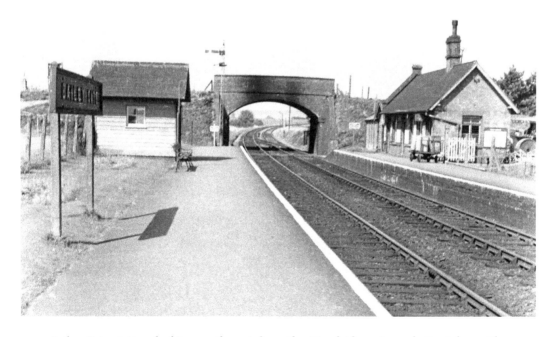

Bailey Gate station, looking north-west from the Up platform towards Spetisbury. The station opened on 1 November 1860 as Sturminster Marshall but was renamed Bailey Gate, apparently to avoid confusion with Sturminster Newton when that station opened in 1863. (Anon, S&DRT)

A March 1991 view of Bailey Gate Bridge looking towards the station site, all of which has now disappeared beneath an industrial estate. Large quantities of watercress were sent north by Messrs Bedford & Jesty from their beds at Bailey Gate, Spetisbury and Blandford.

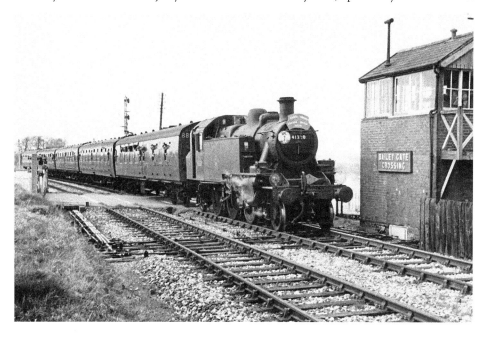

The Manchester Rail Travel Society's Hants & Dorset Branch Flyer special train passes Bailey Gate Crossing signalbox behind Ivatt 2-6-2T No. 41320 on 25 March 1967. The railtour started from Southampton Central and ran on the remaining S&D section from Broadstone to Blandford Forum. (Anon, S&DRT)

Little of Bailey Gate Crossing signalbox remained in March 1991 but the crossing keeper's cottage was still occupied by the former crossing keeper, Fred Andrews, and his family. The site near the busy A31 road is now occupied by a later bungalow.

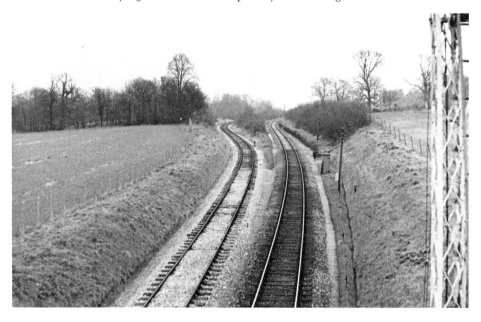

East of Corfe Mullen Junction the 1884 cut-off to Broadstone diverges to the right from the original line to Wimborne. The Wimborne line was closed in 1933 but a section remained in use as a siding until 1959. Corfe Mullen Junction opened in 1905; before then the two lines ran parallel from Bailey Gate station. (John Eyers, South Western Circle, Eyers Collection, via S&DRT)

Brog Street or Glen Lane's Bridge was the first bridge under the line to Corfe Mullen after the junction. Seen here from the south in March 1991, a house has since been built on top of the embankment to the right. The A31 Wimborne bypass now follows much of the original DCR line towards to Wimborne.

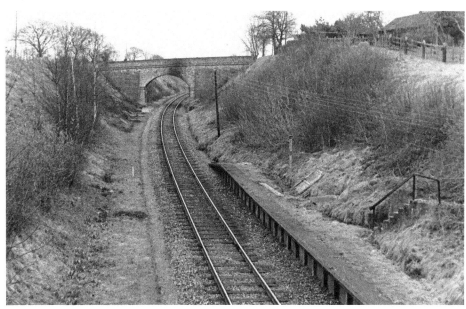

Corfe Mullen Halt opened on 5 July 1928 to serve the residents of East End, a small residential area of Corfe Mullen. The halt closed on 19 September 1956; its remains are seen here in March 1963. All trace of it has now been obliterated as the cutting has been filled to road level and forms the garden of a private residence. (John Eyers, South Western Circle, Eyers Collection, via S&DRT)

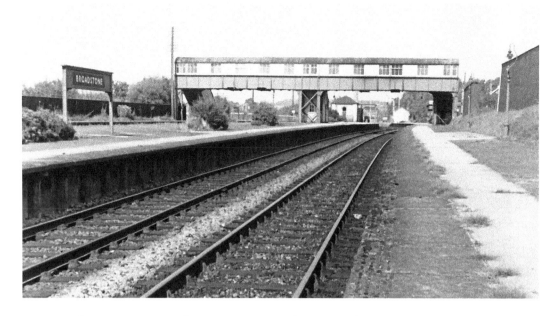

Broadstone station opened on 1 June 1847 on the L&SWR line from Wimborne and had the distinction of being renamed six times before reverting to plain Broadstone in 1956. It is seen here looking north from the Up main platform with the lines from Wimborne on the right. The S&D proper ended at Broadstone and trains ran to Poole and Bournemouth on the L&SWR. (Anon, S&DRT)

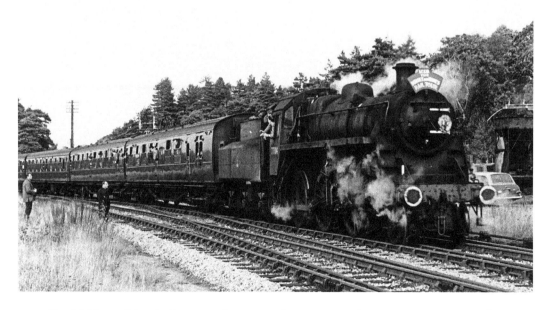

The LCGB special train Dorset and Hants Rail Tour at Broadstone station on 16 October 1966. From Broadstone it ran to Ringwood and back and then to Blandford Forum with BR 3MT 2-6-0 No. 77014 and BR 4MT 2-6-0 No. 76026 (unseen at other end of the train) in 'top-and-tail' mode. (Anon, S&DRT)

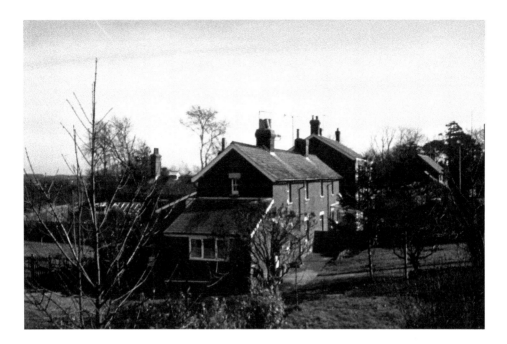

The staff cottages, and drivers' lodging house beyond, south of Wimborne Junction seen from near Oakley Hill Bridge in March 1991; they remain in use as residential properties. The S&D engine shed was located further on, between the lines from Corfe Mullen and Broadstone.

The elaborate Lady Wimborne Bridge between Wimborne Junction and the River Stour Viaduct carried the Southampton & Dorchester Railway (later L&SWR) over Canford Park's West Drive and was crossed by all trains arriving at Wimborne from the south. The drive is now part of the Castleman Trailway.

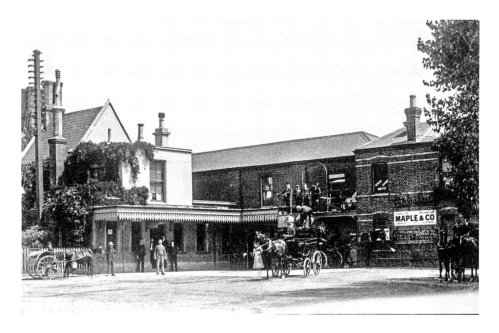

Wimborne station opened on the Southampton & Dorchester Railway on 1 June 1847 and for S&D trains on 1 November 1860. The station buildings and entrance are seen from the west in this early view. The station closed to passengers in 1965 but S&D passenger trains had ceased to use the station in 1933. (Courtesy of the Priest's House Museum & Garden)

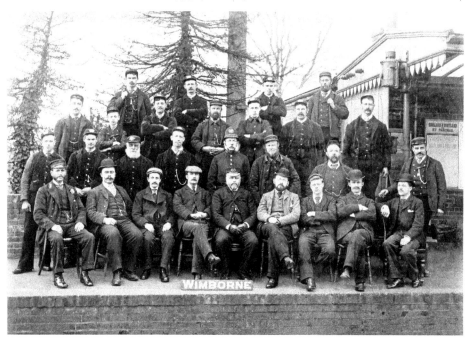

The all-male staff of Wimborne station pose on the platform for this undated group photograph. The Southampton & Dorchester Railway was promoted by Wimborne solicitor A. L. Castleman; the line was nicknamed 'Castleman's Corkscrew' due its meandering route. (Courtesy of the Priest's House Museum & Garden)

Wimborne station from the south, looking towards West Moors, in November 1975. The remains of a short platform used by S&D trains are in the right foreground. The signalbox was closed in November 1966 and demolished; the station closed completely in May 1977. (Anon, S&DRT)

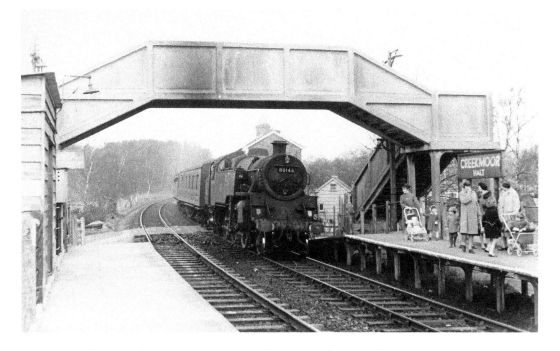

Situated midway between Poole and Broadstone, Creekmoor Halt opened on 19 June 1933, was the last station to open on the route and closed with the S&D. BR 4MT 2-6-4T No. 80146 arrives with a Down S&D train *c.* 1963. (Anon, S&DRT)

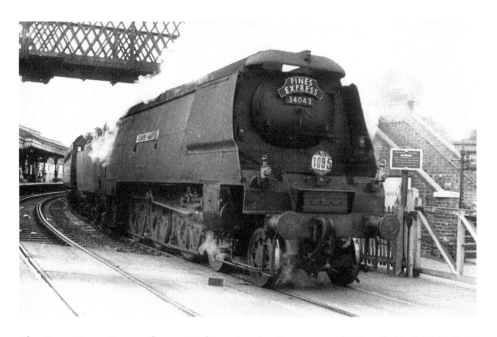

The Down Pines Express leaves Poole station for Bournemouth West behind SR Bulleid West Country Class Pacific No. 34043 *Combe Martin* on 25 August 1962. Poole station was the terminus of the branch from Broadstone from 2 December 1872 until 15 June 1874, when the line was extended to Bournemouth West. The single line to Bournemouth was doubled in 1885. (Anon, S&DRT)

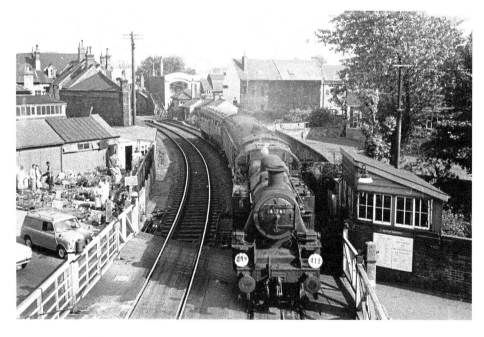

A Bournemouth Central to Weymouth train seen between the two level crossings immediately east of Poole station is hauled by Ivatt 2-6-2T No. 41261 round the sharp curve through the town. The nearer Towngate Street crossing was replaced by the Towngate Bridge in 1971, but High Street level crossing beyond is still in use. (Nigel Davies)

The High Street level crossing is now a pedestrian zone and modern lifting barriers were installed in 1977. Seen from the footbridge just visible in the previous photograph, Desiro Class electric multiple unit No. 444 017 leaves Poole station for London Waterloo in July 2015.

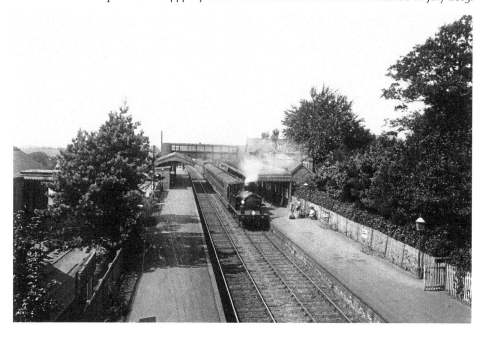

Parkstone station opened on 15 June 1874 as the only intermediate station when the Broadstone to Poole branch was extended to Bournemouth. This early view shows the fully glazed footbridge, built in 1888, with a train showing the L&SWR headcode for a Dorchester to Bournemouth Central service. (Poole Museum Service)

Viewed from the now unglazed footbridge, Desiro Class electric multiple unit No. 444 023 arrives at Parkstone station with a train for Weymouth in July 2015. The station closed to freight on 20 September 1965 and the goods yard is now a residential development.

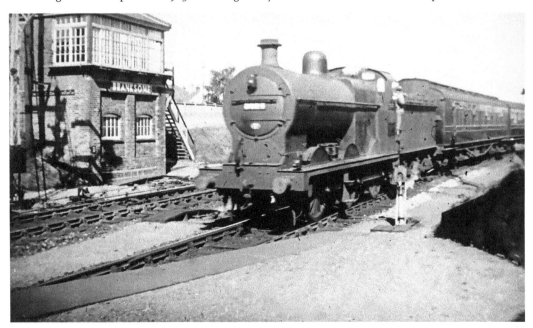

Branksome station opened on 1 June 1893 when the new junction immediately east of the station allowed trains to run direct from Poole to Bournemouth East (Bournemouth Central from 1899). A Bournemouth West to Bath passenger train arrives on 4 September 1937 behind Fowler 4F 0-6-0 locomotive No. 3924 (now preserved). (Anon, S&DRT)

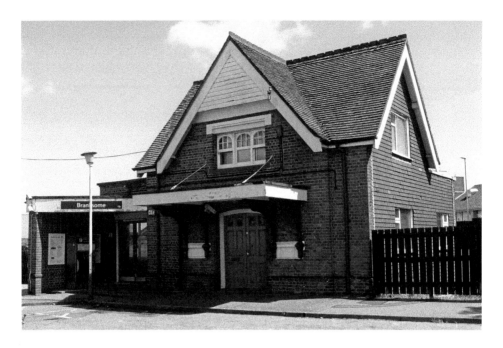

Following the closure of Bournemouth West station in 1965, some S&D trains terminated at Branksome. The station entrance is at road level with the platforms, in a cutting below, being reached by steps from the covered footbridge. The S&D engine shed was located within the triangle of lines to and between the two Bournemouth stations.

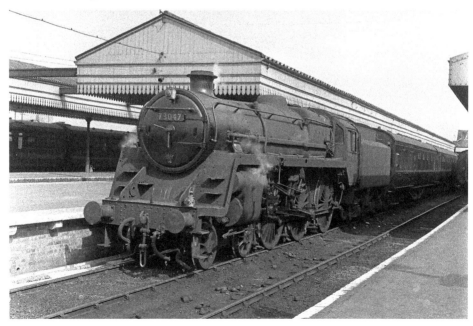

Bournemouth West station opened on 15 June 1874 and was the southern terminus for S&D trains as well as trains from London Waterloo and local trains. Around ninety years after opening, BR 5MT 4-6-0 No. 73047 stands at platform No. 3 with a train for the S&D line. (Ted Salthouse)

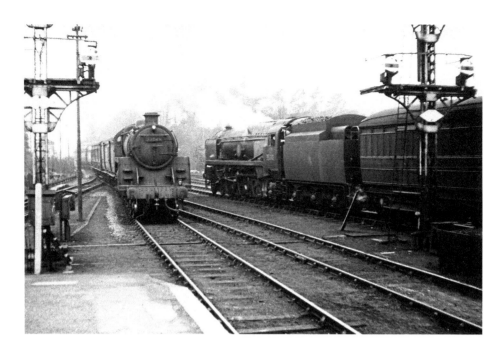

Arriving at Bournemouth West with a Down semi-fast S&D train is BR 5MT Class 4-6-0 No. 73049 on 25 April 1957. SR Bulleid Merchant Navy Class Pacific No. 35010 *Blue Star* stands with a train for the SR main line. The station was officially closed on 4 October 1965 and later demolished. The approach to the station is now occupied by Bournemouth train care depot and the station site itself is a car park. (David Milton, S&DRT)

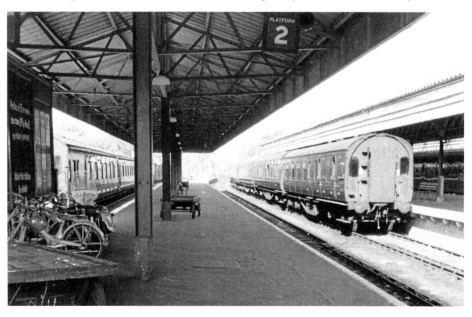

Bournemouth West station, looking north along platform Nos 1 and 2, in the early 1960s. The station originally had just two platforms and was extended to six when the line from Poole was doubled in 1876. The numbering of the platforms was reversed in September 1931. (Anon, S&DRT)

Acknowledgements

I am very grateful to the following who read draft text at various stages and kindly commented on content and style: David Grimwood, John Buxton, Stuart Mullins, Richard Gunning, Kate McStraw, Jonathan Edwards and Ruth Gillett. I have made extensive use of the published histories of the S&D, principally Robin Atthill, *The Somerset and Dorset Railway* (David & Charles, 1985) and also C. W. Judge and C. R. Potts, *An Historical Survey of the Somerset & Dorset Railway* (Oxford Publishing Co. 1979). Useful information has been garnered from Mac Hawkins, *The Somerset & Dorset Then and Now* (PSL, 1986) and the relevant volumes in the Vic Mitchell & Keith Smith, *Country Railway Routes* series (Middleton Press). Robin Summerhill, *Cycling the Somerset & Dorset Railway, And a survey of the line in 2013* (Summerhill, 2013) was a useful source of information about the recent state of the railway. The *Pines Express* bulletin of the Somerset & Dorset Railway Trust (S&DRT) is a wonderful source of information about the railway, as is the Somerset & Dorset Railway Heritage Trust's bulletin *Telegraph*. I have not consulted primary sources to any great extent, but am grateful to the staff at Somerset Heritage Centre for providing access to early plans and have also drawn on archive material held by the S&DRT including digitised copies of minutes of company and officer meetings. I have tried to ensure that the information is correct, but of course take full responsibility for the end result and any remaining errors.

I wish to thank the following for permission to use images in this book: Colin Johnston (Bath Record Office), Kate McStraw, Ted Salthouse, Dave Brown, Kevin Mitchell (Spetisbury Station Project), James Webb and Dave Keig (Priest's House Museum & Garden), Katie Heaton (Poole Museum Service) and Nigel Davies. I am especially grateful to the S&DRT for access to and use of their extensive photograph collection and am pleased to bring some of this material to a wider audience for the first time. Keith Barret of the Trust needs a special mention for his years of work identifying the subject matter of the images.

Every attempt has been made to seek permission for copyright material used in this book. However, if we have inadvertently used copyright material without permission or acknowledgement we apologise and we will make the necessary correction at the first opportunity.

Steph Gillett
September 2015